Draw Flowers

Anne Pieper

Draw
Flowers

SEARCH PRESS

Preface

Welcome

Painting and drawing are my favourite creative activities and, above all else, I am fascinated by flowers and blossoms. I always have a sketchbook on me in which to record my impressions when I am out and about, as this allows me to work up the sketches in peace and quiet at home, whatever the season, sheltered from any bad weather. Most of you will have some talent for drawing – but talent alone is not enough. Practice makes perfect! In this book I am happy to share with you the experience that I have accumulated over the years. If you have never done any drawing before, you should begin with the basic principles in Part One. Should you have some experience of drawing, you can go straight to Part Two. In this part you will find the most important botanical information for each flower, along with detailed studies and practical exercises. This will enable you to gain some basic knowledge of botany, which you will be able to transfer graphically to each flower. The better you get to know a flower, the easier you will find it to draw. Look very closely at the details and make lots of sketches. This will sharpen your powers of observation, and make reproducing what you see come naturally. You will be astonished by how much you are about to discover!

I am sure you will have many hours of enjoyment and I wish you every success with your drawing.

Contents

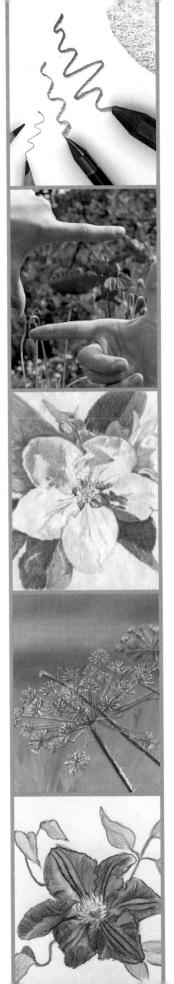

Part One:
Materials and techniques

Mastering the interaction between materials and techniques is a prerequisite for any kind of painting and drawing. Even though you will learn about the exact materials and techniques that you need to use from the pictorial exercises in Part Two, you should start by applying the basic principles of the art of drawing presented in Part One. It is best to try out the techniques for yourself. Start with uncomplicated materials, such as a pencil and basic drawing paper, or draw large strong lines on wrapping paper with charcoal. You will be astonished by the possibilities! There are plenty of examples on the following pages.

Artists' materials

The quality of your materials will determine the quality of the result. Choose your materials carefully. When it comes to paper and crayons, there is a distinction between economical student and art-school-quality materials for beginners and top quality ones for professional artists.

Pencils

The pencil is the most common of all drawing tools. Finely ground soft graphite is blended into the pencil lead. The higher the graphite content, the harder the pencil lead will be. The harder pencil leads in grades from H to 10H are predominantly used for technical drawing. The soft pencil grades from HB to 8B are much more suitable for artistic purposes. If you want to make optimum use of the properties of a pencil, the three HB, 2B and 5B grades will be all that you need.

Graphite pencils

Graphite leads give denser lines than pencils made from a clay and graphite mixture, but the lead breaks much more easily, so propelling lead holders are particularly useful. These pencils are very handy for large drawings with large coloured areas; you can use broken pieces of graphite as well. Graphite leads are protected on the outside by a thick coat of lacquer. Mechanical pencils that do not need sharpening are available too. Graphite and pencil can easily be erased and wiped across the paper.

Colour pencils

Colour pencils are smudge-proof and waterproof. You can buy them as single pencils or in boxed sets. Because colour pencils are not completely opaque, use a pastel crayon or soft white chalk pastel sparingly to brighten colours. Set up the drawing with a thin pencil line. You can mix and blend colours by applying layers of different hues. Cross-hatching also creates interesting effects.

Watercolour pencils

Watercolour pencils are pencils with water-soluble leads. They are used to create a more fluid colour than is possible with colour pencils. You can either first apply the colour with a pencil and then work it with a wet brush, or moisten the paper first and then draw the colour on. The colour will flow and blend whichever method you use. Watercolour paper should be used for this technique.

Pastels

Pastels are available in round or square sticks, and are chalky and soft. Backgrounds are quickly and easily filled in by using the flat side of the pastel, while the edge or point can be used to create fine lines and detail. The colour density varies with the amount of pressure applied. Chalk pastels can be mixed very easily by scumbling the colours in layers, and you can create an even patch of colour by smudging. Chalk breaks easily. Pastel colours must be fixed with a fixative.

Watercolour crayons

Watercolour crayons are water-soluble wax crayons. They mix together easily and quickly. The strength of this medium allows much more pressure to be used. Water-soluble crayons offer exceptional colour brilliance as well as a high degree of colour- and light-fastness, and the colour applied can be very intense. The colour brilliance increases even more when it is mixed with water. These colours make great impact and are best used for larger works.

Charcoal

Charcoal is a very responsive drawing medium – just the lightest touch on paper leaves a mark. Charcoal is particularly appropriate for large and quick sketches and a certain expressive kind of line. Charcoal is very easily smudged, so you can create a huge gradation of greys. Rougher paper is most suited to this medium because it binds pigment well and its own texture enhances the effect of the charcoal. There are several kinds of charcoal:

Natural charcoal is a short piece of willow twig that has been carbonised in an airtight kiln. You need to pay very close attention to the quality of the charcoal. It should neither scratch nor crumble when you draw with it.

Charcoal sticks or ground charcoal are manufactured by firing a mixture of wood charcoal, clay and a binding medium. As with pencil leads, this produces distinct grades of hardness and therefore there are many different ways of applying the colour.

Charcoal pencils are encased in wood, like other pencils. As charcoal crumbles so easily, it should be sharpened with a sharp knife, and the tone can be lightened with the help of a putty eraser. It is absolutely essential to fix the finished drawing.

Paper

Paper is the foundation for every artistic endeavour. Its surface texture shows through the layers of colour. But the power of colour modifies that texture and it therefore becomes an important component of the drawing. The paper for the projects in this book can be chosen from the following:

Sketching paper

Sketching paper comes in several formats, from simple spiral-bound pads to luxury leather-bound sketchbooks. If you like to do a lot of sketching when travelling, you should take this into consideration so that you have a suitable format to hand at all times.

Drawing paper

For a detailed black or colour-pencil drawing, finely grained drawing paper is best. Although the surface can be quite smooth, it should have a fine grain to guarantee good colour adhesion. Good sketching paper shares these attributes. Drawing paper is available in white and coloured versions, in various weights.

Watercolour cartridge paper

Watercolour paper, cartridge paper or uncoated card or board are best for wet techniques. Matt and glossy papers have quite a smooth surface, which is particularly good for wet techniques that cover large areas. Coarse and ultra-coarse paper can help to create interesting effects because of their distinctly grained surfaces.

Pastel paper

Pastel drawing paper is also available in many different colours with various surface textures, from smooth to corrugated. This gives optimum colour retention and pigment adhesion. The soft surface is designed for mixing, rubbing and layering the colours of chalk pastels.

Mounts and frames

A mount and a frame not only protect your drawing against damage, but above all give maximum impact to the artistic form. You can also change the mood of a picture with a mount and frame. Selecting the right frame for your picture requires a lot of care and understanding of colour and tone.

Mounts

Mounting boards are available in all sizes and colours. Using a sample set of angled squares makes it easier to decide what colour would suit your picture before you select an appropriate mount. You can also lay your drawing on a piece of coloured paper before you decide on the colour of the mount.

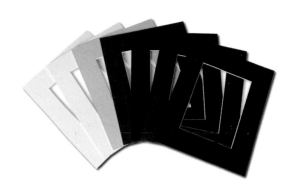

You can easily make a mount yourself. You need a sheet of art paper or cartridge paper no lighter than 160g/m² to make a simple mount. For a drawing of around A4 size, the sheet should not measure less than 30 × 40cm (12 × 16in). You will also need a cutting surface, a metal ruler, adhesive tape and a cutter (craft knife or paper trimmer).

How to do it:
Measure the finished drawing and make a note of the dimensions, subtracting a few millimetres or even a centimetre. The picture will need to be placed under the mount at a later stage. Draw the shape in a fine line with an HB pencil on the back of the mounting or cartridge paper. Place the paper on the cutting surface, place the ruler on the paper, and run the cutter along the ruler until the paper is cut. Be careful at the corners! Take out the cut part in the centre and turn the mount over. Place the picture over the cut-out window and stick it provisionally with a piece of adhesive tape. Turn the picture over and assess the fit of the drawing in the mount; change it if necessary. When you are happy with it, stick it down with adhesive tape on two sides only and press home. Remove the temporary tape.

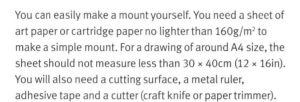

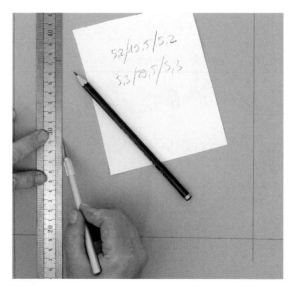

Frames

To complete your picture you will need to fit a proper frame. That way your art is protected and is presented in an appropriate way. You could use a lacquered clip frame with glass, or a white wood frame that you can paint in a colour to match or offset the drawing. If you are buying a ready-made frame, always take your picture to the dealer or framer in either a portfolio or an art folder.

Drawing tools and equipment

Besides drawing, these tools can also be used for certain other techniques. Familiarise yourself with the wide-ranging applications of your drawing tools and equipment, and pay particularly close attention to their maintenance and their quality!

Brushes

You will require brushes for certain pictorial exercises, to paint the layers that are applied with watercolour pencils or to blend chalk pastels.

Erasers and putty erasers

You need to look for quality even with erasers and putty erasers. Always check that your eraser is clean before using it.

Pencil sharpeners

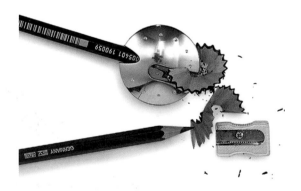

A good pencil sharpener gives lead pencils, as well as colour and watercolour pencils, a proper point. For softer leads you can either use a knife (or scalpel) or a sharpener, as you prefer.

Knives

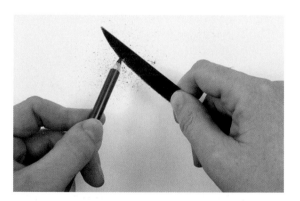

A knife is much better for chalk and charcoal pencils as it permits light sharpening, although the minerals in the lead will quickly blunt blades.

Other tools

All charcoal and chalk or pastel drawings must be preserved with fixative. Fixative builds up a protective layer. When you work with these drawing media, you may want to fix the picture in the course of drawing it, so that nothing is inadvertently rubbed out. You can draw and paint over the protective film after only a brief drying time. The final fixing should be applied over the entire sheet of paper. Work from the top to the bottom so that you apply a thin even layer on to the paper. Do not be over-generous with the fixative as too much of it dulls the colours.

If you want to trim your own drawing paper or mounts, you will need a cutting mat, a ruler and a knife or scalpel.

How to hold your pencil

Try both the following ways of holding the pencil with varying pressures, once with a colour pencil and once with an ordinary pencil. This helps you to gain confidence and develop a routine when using pencils, which is essential in a well-balanced drawing.

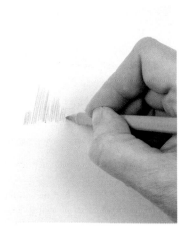

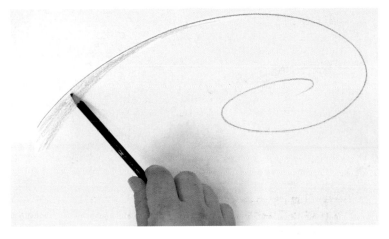

Writing grip: when drawing small subjects or patterns, the usual writing grip should be used.

Broad hold: hold the pencil well down its length. Draw with a loose movement from your wrist. This enables you to make quick sketches, large cross-hatchings and long, broad, drawn-out lines.

Exercises

Light colour application: hold the pencil loosely in your hand. Draw with only the lightest of pressure. Create cross-hatchings and lines with light and even colour intensity.

Stronger colour application: start the stroke with increased pressure and lighten the movement halfway down the line. You are now creating gradations of tone in planes and in lines.

Carry out the following pencil-stroke exercises with different pressures. Experiment with ordinary pencils, and with colour and charcoal pencils, on various types of paper.

straight lines *curved lines* *crossed lines* *scribbled areas* *stippled areas*

Hatching and shading

In the art of drawing, hatching and shading have a very special significance. You can mimic a surface texture with the right hatching, create effects of light and shade, blend colours, and above all give shape and depth to a drawn object. It is worthwhile carrying out several hatching exercises with different pencil hardnesses.

Simple hatching

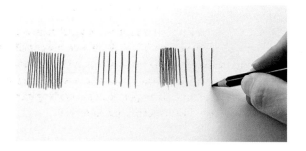

Hatching consists of lines drawn parallel to each other. The further the lines are drawn apart, the lighter the hatching will look; it will appear darker with the lines drawn closer together. For example, you could gradually change from close to wide spacing while keeping the pressure the same.

Quick hatching

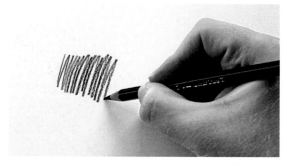

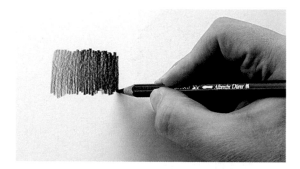

Quick hatching is done by drawing all the lines without taking the pencil off the paper. Draw the lines evenly and close together so that you achieve an almost even coverage. Use the lead sideways or use a blunt pencil for even cross-hatching so that the pencil stroke becomes broader. You can also alter the pressure on the pencil and achieve a transition from light to dark with this technique.

Cross-hatching

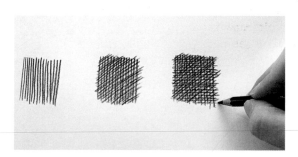

In proper cross-hatching, parallel lines are put down first, and a further set of parallel hatched lines are layered over them at a different angle. Draw an increasing number of layers over each other – the more there are, the denser and darker the cross-hatched area will become. For very large areas it is appropriate to overlay the hatching at stepped angles of 45 degrees; this will give the hatching an even appearance.

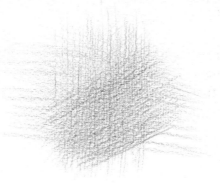

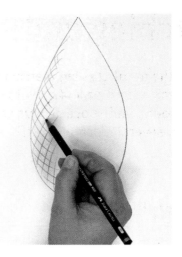

Single colour cross-hatching is simple to achieve with colour pencils, but different hues can also be layered over one another. Use only a light pressure for the cross-hatching; it is easier to control the colour saturation in this way, and the area will have a more balanced look. This works even better if you rub or smudge the colours with a tissue.

Cross-hatching can be done equally well with a colour pencil or an ordinary pencil. With ordinary pencil the cross-hatching is used mainly to draw the shadows in the pictures. This means that the cross-hatching has to follow the shape. Lead pencil cross-hatching can be smudged with a finger or a paper tissue.

Rendering

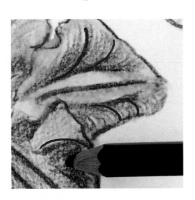

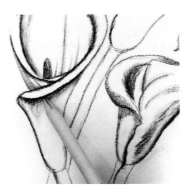

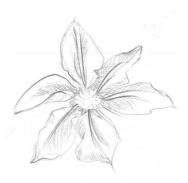

When rendering, the direction of the lines need to follow the natural form. This shows the roundness and sides of objects and gives them a three-dimensional quality. The hatching can be either simple hatching with regularly spaced lines or cross-hatching.

You can continue to work on the texture of the surface with rendering and at the same time make shadows and shade. The texture disappears almost immediately depending on how strongly the lines are smudged, and instead you will create a smooth and even patch of shadow that is darker around the edges.

The upper surfaces of this flower display a lot of different shapes and tonal values but with the same texture. The line direction follows the shape and curve of the leaves. The shadows on the petals are established by making the hatching denser.

Techniques

You can use your drawing materials in many different ways once you have total command of the corresponding techniques. The result is a sophisticated interaction between material and colour, producing lots of interesting effects. Try a particular technique out before you use it directly in your drawing.

Wiping and rubbing

Shave off some fine slivers from your pencil with a sharp knife.

Fix the colour dust and shavings on the paper by grinding or rubbing them in.

The delicate colour patches may also be made up of several colours.

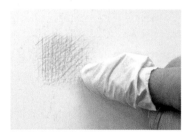

Layers of pencil and colour can be mixed easily with a paper tissue or...

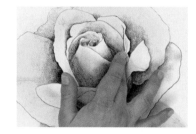

... with one or more fingers. Make sure that your hand does not rest on the drawing.

When you blend chalk pastel with a brush, you can create a texture at the same time.

Erasing and creating highlights

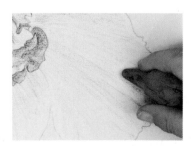

You can create detailed highlights with a putty eraser shaped into a point.

The putty eraser can take off just a little or quite a lot of colour, depending on the pressure applied.

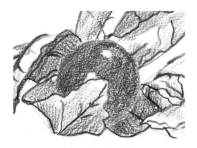

You can mark the highlights with thin pencil lines and then erase them later to create highlights.

Shading

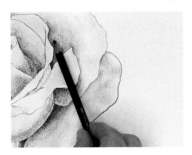

For even and gradual shading you should move the pencil across the paper with very little pressure.

Irregular gentle movements, holding the pencil at the end or in the middle, will help to create small areas of shading.

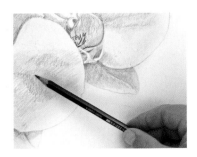

For very thin layers of colour you should hold the pencil as flat and as broad as possible.

Watercolour

Watercolour pencils and watercolour paper or board should be used for this technique. There are several possibilities for creating watercolours. For the drawing projects in this book, proceed as follows. Draw your intended design or a patch of colour with watercolour pencils on dry paper and then dissolve the layer of colour with a wet or moist brush. Draw the brush with a few strokes across the area to be coloured (see illustration opposite). Leave any bright spots almost completely blank (see illustration below).

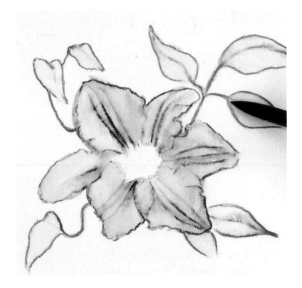

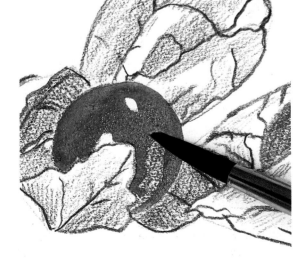

Under no circumstances should you just brush over the drawing randomly or the drawing will simply disappear. Paint with rapid strokes, because the pencil paint dries very quickly and the colour could accumulate in unsightly edges.

Perspective

A flower will offer you entirely new perspectives according to the angle of view. In order to represent the flower properly, you will have to select the correct perspective. Draw the most simple and basic geometric shape as the outline and draw in the axes of symmetry. The perspective of this geometric pattern shows you the correct optical foreshortening. After that you will be able to draw in all the flower details. As an example you can see here all the steps in drawing a gerbera.

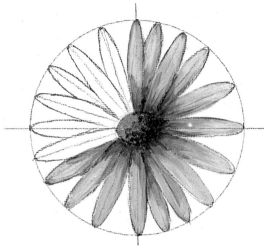

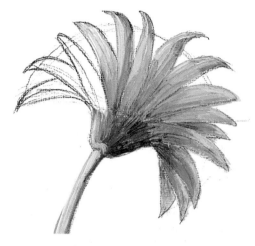

Image of a flower seen from above
The circle is an extremely helpful shape when drawing a picture of a flower from above. Look carefully at how the individual flower petals are arranged neatly one behind the other. Emphasising each individual flower petal makes the representation especially three-dimensional.

Image of a flower seen from below
The back of the flower shows how the stem is attached. The petals merge into the stem where the colours of the flower also change to green. The stem ends below the calyx. This line runs in a curve around the stem.

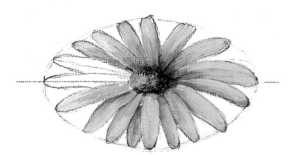

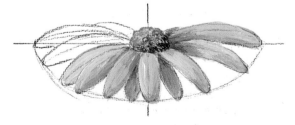

Image of a flower seen at an angle from the side
In a side view the centre point of the flower lies on the central axis. Here an ellipse helps with the accurate depiction of the petals. The individual petals are always drawn pointing into the centre of the flower.

Image of a flower seen from the side
The centre point of the flower also becomes the central axis. The individual petals are again drawn pointing into the centre of the flower. When there are several flower heads you should draw one after the other.

Circles and ellipses

When you draw an object in perspective and you transpose it into its basic geometric shapes, the circle will almost always emerge.

Practise drawing circles and ellipses! The larger the paper, the more fun you can have with a drawing. Packing paper and (unprinted) newspaper are excellent for practising.

If you draw a square first, it is easy to draw a precise circle by fitting it into the square. Draw in two central axes, a horizontal one and a vertical one. These set the position and help in the construction of the drawing. The intersections give you the centre as well as four points on the curve of the circle.

When perspective is applied to the square, the circle will then appear as an ellipse. Depending on the angle you are looking from, the ellipse will become rounder or flatter. The ends are always rounded and never pointed.

Underneath the squares, you can see several flowers that are subdivided into four, five and six segments. When you get round to drawing, this method of dividing an image is really helpful for analysing form and shape. However, never just follow a diagram, but always make careful and precise observations: nature often breaks the rules a little and that is exactly what makes nature so stimulating.

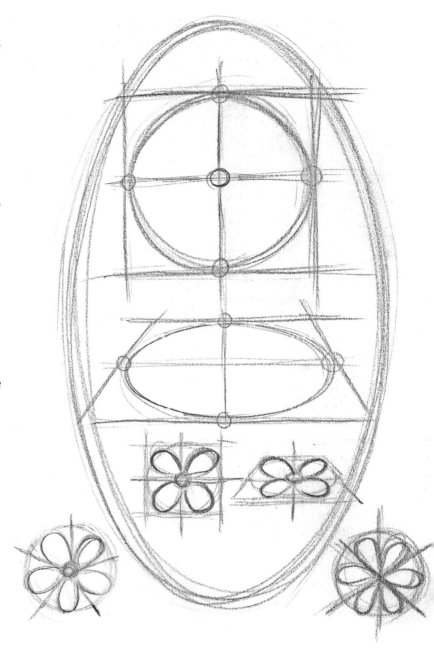

Ribbons

Sketching ribbons is an important exercise that will help in the drawing of leaves and the ruffled parts of blooms. Lay a 40mm (1½in) wide ribbon in a medium tone of any colour on the table with various curves and twists. You can also do this with a belt or a strip of paper. Try to draw the shadows as precisely as you can.

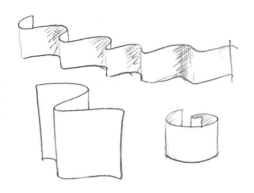

You can do this exercise without an actual model in front of you. Draw two wavy parallel lines, one above the other. Experiment with different widths between the wavy lines.

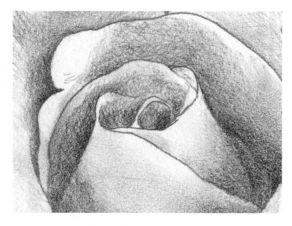

The petals in the centre of a rose, for instance, look like rolled-up ribbon. You can also draw the blooms of the Calla lily in this way.

Both these tulip-shaped leaves feature a rotation similar to a twisted ribbon. Look at the centre line: it ends at the bend in the leaf and then starts again in a different place to run down the rest of the leaf.

Form

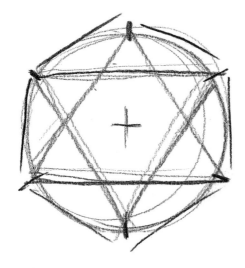

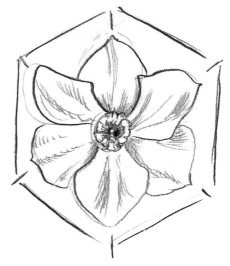

In order to capture an object more quickly and not to be distracted by details, you need to take the principal forms back to their basic and fundamental shapes. For most flowers, this is a circle.

Flowers often have three to six petals, so divide the circle into the same number of triangles. You can represent the actual forms with lines and by adding shadows.

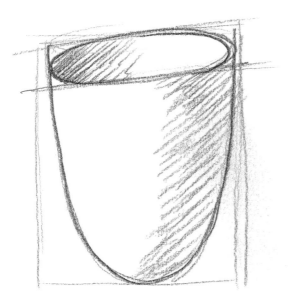

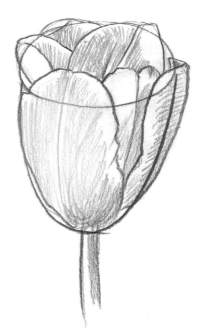

In the case of flowers that have a cone-, cylinder- or cup-shape as their root form, for instance the tulip, you will need to create a shadow in order to obtain a three-dimensional effect.

Sketch the outlines of the petals with a thin pencil line. Decide where the darkest and the lightest sections are, then apply shading as hatching to create the shape of the flower.

Composition

Image sections and composition are inseparable. You should therefore decide on the image section and sketch in the various possible compositions before you start the drawing properly. Experiment with the format as well.

Defining the subject

Cut two L-shaped right angles from strong cardboard. These two right angles will enable you to decide on the picture area and format it in a playful way.

Even easier: make two right angles with your thumbs and fingers and put them together to frame the picture you want, just as you would do with the cardboard right angles.

Structure

When choosing the field of the picture, you should try to create tension, without which the picture would be boring. Tension can be created by combining contrasting elements, as in this drawing of an orchid. The strong static lines of the twigs contrast with the organic rounded flowers.

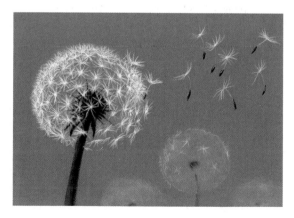

The tension in the dandelion picture is created by placing the most important pictorial element not in the middle, but towards the side.

Sketching

When you sketch an object, you should try to find its essence from the start – the typical features and the essential shapes of the objects you have selected – so you can rapidly get it down on paper. This helps to train your eye to see an object's real essence and requires you to work in a swift and loose fashion with your pencil. It is best always to have your sketchbook handy.

10 Sekunden

5 Minuten

Sketching is more successful if you tell yourself that a sketch has to be finished in only a few seconds. Start out every time with this intention firmly in mind, so you do not get lost in the details. A very good exercise is to start by taking just ten seconds to sketch an object, then draw the same thing again taking five minutes, followed perhaps by another five minutes to make a detailed sketch of the object. For instance, single leaves, a leaf and a petal, or a flower bud are good subjects for sketching details of plants. Leave the eraser to one side right from the start, so you do not interrupt the flow of the drawing action. It is essential to master swift drawing because it will then be easier to sketch subjects that are in motion or which change.

Sketching paper comes in spiral-bound pads or pads with glued backs in several formats, colours and qualities. Try out various kinds.

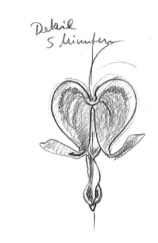

Detail
5 Minuten

Light and shade

On paper, a two-dimensional object becomes three-dimensional when you bring light and shade into it. The different densities that you apply with this technique are called tonal values. They are perfect for developing mood and atmosphere.

Tonal values

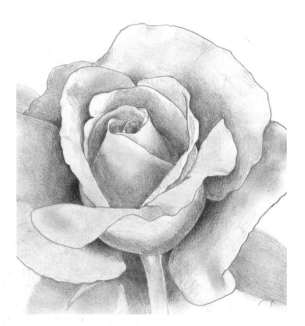

Contrasting light and dark tones are best for creating moods. Dark tones will yield a threatening atmosphere. Strong contrasts develop in the glittering light of a summer's day, while subtle colours and soft contrasts remind one of spring. Tonal values also help achieve depth: dark objects come forward and light ones recede. To make it easier to distinguish the light and shaded sides of an object, you should create a clear interplay between the shapes by illuminating the picture's subject from one side only. The shadows become more intense and therefore easier to pick out. But the light must not be so strong that it swallows up the details of the form and shapes.

Tip: Look through half-closed eyes and you will immediately see the image simplified into its light and dark parts. The forms and shapes can clearly be picked out. Cast shadows (see illustration below left) also reinforce the three-dimensional effect.

Shadows

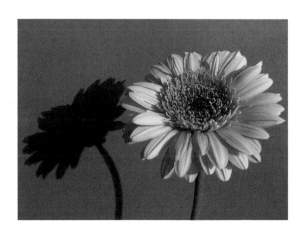

When light strikes a flower, it casts a shadow on the ground or the background. This is called a cast shadow. Every object on to which light falls produces its own array of shadows on the side turned away from that light. Recesses are also filled with shadows.

It is often quite difficult to achieve highlights by reversing them out during the drawing process. You can create these areas later with a kneadable eraser. You need to give your kneadable eraser a pointed end or make it flatter, depending on the shape of the area and its tone. You can decide how much colour or graphite you remove by varying the pressure on the eraser.

Light

Sunlight makes for sharp shadows. A cloud-covered sky makes shadows soft and diffused. Artificial light throws distorted shadows, which become weaker as the light is moved further away from the subject.

When you are sketching outdoors, the light can change very quickly. That is why you should capture the scene with a few broad strokes. Do not attempt to adapt the sketch to the changing light conditions.

Grey scale values

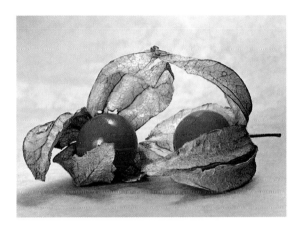 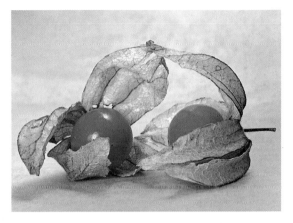

If you wish to transform a coloured subject into a graphic image with a pencil or graphite stick, you will have to translate the tonal values into a grey scale. In its simplest form this can be done by making a black and white copy of a colour photograph or converting it by digital means.

When you draw from nature you will not be able to convert the image to black and white so easily. Instead, perform the squinting trick with your eyes half closed and look through your eyelashes. You should now be able to see clearly where the highlights and the shaded parts are. Start on the light sections when drawing.

Highlights

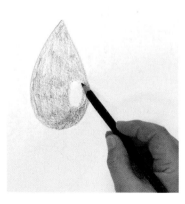 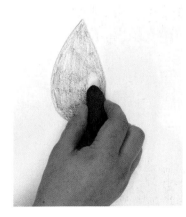 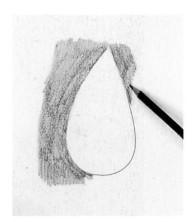

Highlights give your drawing depth and liveliness. It is easiest to leave these patches free of colour from the start. You can also lighten these areas afterwards with a kneadable eraser.

Many beginners draw the outlines too strongly. Such lines do not exist in reality. Make the lines lighter and darken the contours in accordance with the background.

For bright objects, pencil the outline very lightly. This is only for positioning: the background can then be darkened around the outline.

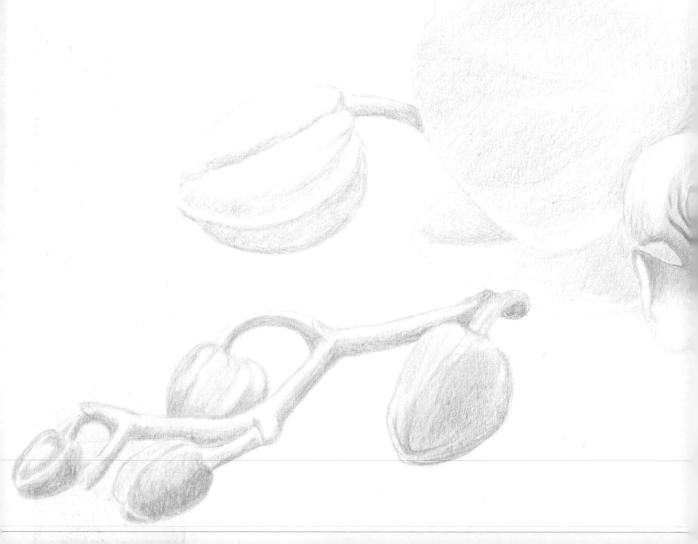

Part Two:
Detail studies and drawing projects

As well as knowing about materials and techniques, good powers of observation are also a fundamental part of your drawing equipment. You can train yourself anywhere, every day, by sketching both whole objects and details. You can also improve your powers of observation by acquiring information about the subject of your drawing. You will find out in this part how you can, for example, use botanical knowledge about flowers and blossoms to create drawings. First you will learn how to get to know the details of a flower before you draw it as a whole. The better you know your subject and the better you can see it, the easier you will find it to draw.

Tulip

A tulip adopts a variety of shapes as it grows: from the pointed bud through the compact cup shape to the widely extended flower bowl. It is best to start from clearly defined fundamental shapes when you draw a tulip.

Bud

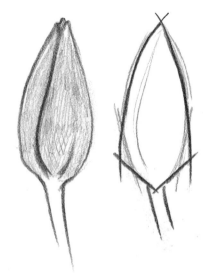

The bud starts out green and has a narrow, pointed shape.

Stems and leaves

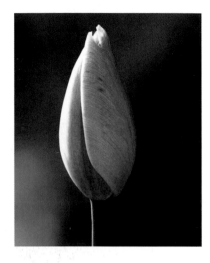

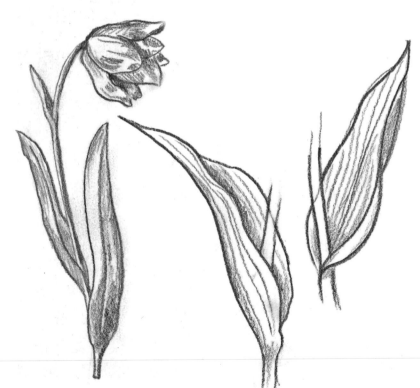

The powerful, round stem rises without dividing from the bulb to the base of the flower. Three to four leaves wrap around the stem. The leaves have a concave form, but become flatter with age. After the flowers have bloomed the leaves fold entirely outwards. The leaf veins run parallel to the leaf edge.

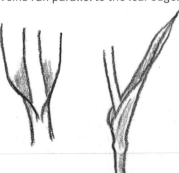

Light

Sunlight makes for sharp shadows. A cloud-covered sky makes shadows soft and diffused. Artificial light throws distorted shadows, which become weaker as the light is moved further away from the subject.

When you are sketching / very quickly. That is why yo with a few broad strokes. Do no sketch to the changing light conditio

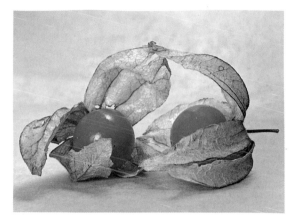

Grey scale values

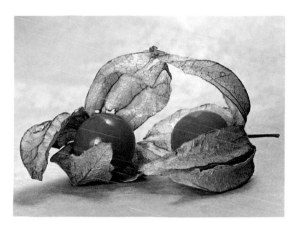

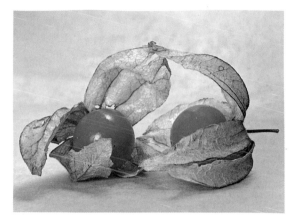

If you wish to transform a coloured subject into a graphic image with a pencil or graphite stick, you will have to translate the tonal values into a grey scale. In its simplest form this can be done by making a black and white copy of a colour photograph or converting it by digital means.

When you draw from nature you will not be able to convert the image to black and white so easily. Instead, perform the squinting trick with your eyes half closed and look through your eyelashes. You should now be able to see clearly where the highlights and the shaded parts are. Start on the light sections when drawing.

Highlights

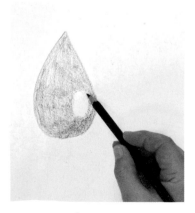

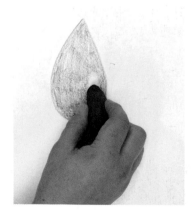

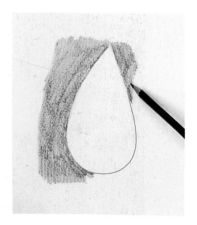

Highlights give your drawing depth and liveliness. It is easiest to leave these patches free of colour from the start. You can also lighten these areas afterwards with a kneadable eraser.

Many beginners draw the outlines too strongly. Such lines do not exist in reality. Make the lines lighter and darken the contours in accordance with the background.

For bright objects, pencil the outline very lightly. This is only for positioning: the background can then be darkened around the outline.

art Two:
Detail studies and drawing projects

As well as knowing about materials and techniques, good powers of observation are also a fundamental part of your drawing equipment. You can train yourself anywhere, every day, by sketching both whole objects and details. You can also improve your powers of observation by acquiring information about the subject of your drawing. You will find out in this part how you can, for example, use botanical knowledge about flowers and blossoms to create drawings. First you will learn how to get to know the details of a flower before you draw it as a whole. The better you know your subject and the better you can see it, the easier you will find it to draw.

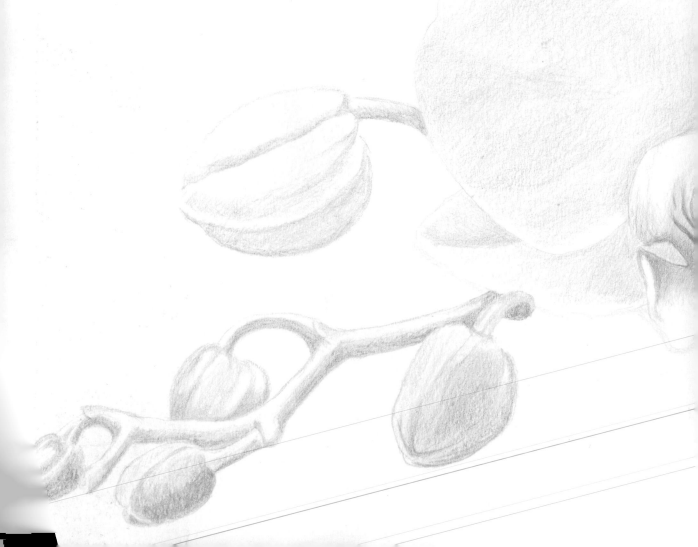

Tulip

A tulip adopts a variety of shapes as it grows: from the pointed bud through the compact cup shape to the widely extended flower bowl. It is best to start from clearly defined fundamental shapes when you draw a tulip.

Bud

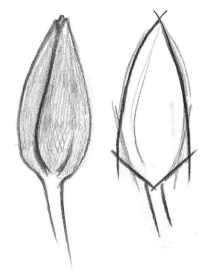

The bud starts out green and has a narrow, pointed shape.

Stems and leaves

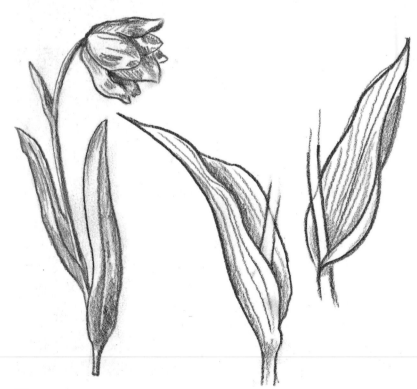

The powerful, round stem rises without dividing from the bulb to the base of the flower. Three to four leaves wrap around the stem. The leaves have a concave form, but become flatter with age. After the flowers have bloomed the leaves fold entirely outwards. The leaf veins run parallel to the leaf edge.

Flower shapes

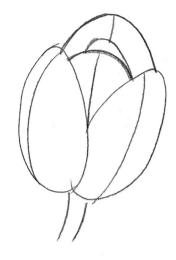

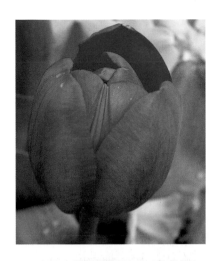

You can clearly recognise the structure of the petals in the young flower. The individual petals appear as simple oval shapes.

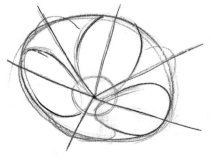

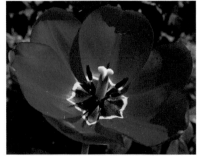

This flower has the classic tulip shape, as drawn by children. The petals are not pointed, but rather bend like scales inwards into the flower. The sketch clearly shows the bowl shape of the young blossom.

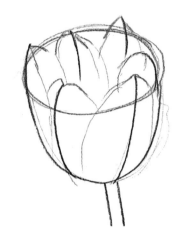

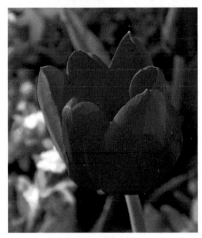

The bowl-shaped open bloom shows the oval petals. A vein bisects each petal from the base to the nick on the edge. The outline of the entire bloom is round – but oval if viewed at an angle from above.

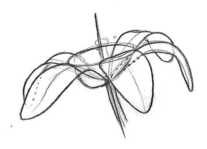

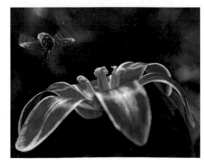

Here the petals bend strongly outwards. They make a flat dish, with the stamens and pistil in the centre. They curve into soft triangular shapes.

Flower structures

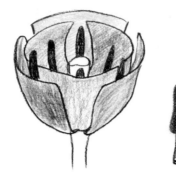

These drawings show the structure of the flower. The pistil is surrounded by six stamens. There are three petals around the stamens and another three outer petals offset between the inner petals.

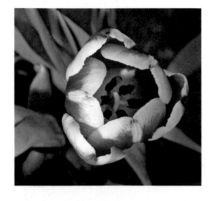
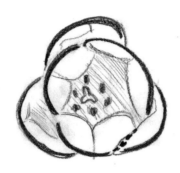

Real flowers are less precisely arranged than shown in the drawings. The curves of the petals have been emphasised here for clarity. The petals each form a rough triangle.

Inner bloom

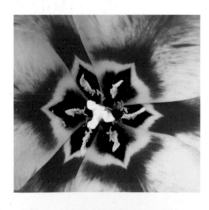
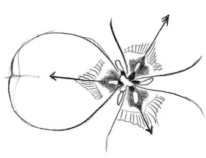

The bright stamens stand out clearly from the dark background. The drawing of the inner flower is made up of triangular shapes that are symmetrical around the central axis of each petal.

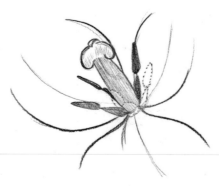

The thick, light-coloured pistil is situated in the middle of the receptacle. Six stamens grow upwards from the base of the pistil. The stamens are also directly connected to the pistil.

Drawing project

Materials: *drawing paper, handmade watercolour cartridge paper (300g/m²), watercolour brush (no.14), 4B pencil*
Water-soluble wax crayons: *blue-green, dark red, light yellow, light red, May green, maroon, reddish-orange*

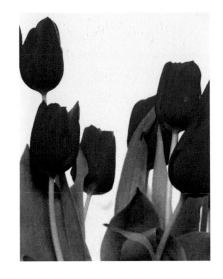

1. Capture the basic shapes of the tulips in a simple pencil sketch on drawing paper. Take a look at this sketch from time to time while you are working on the actual picture.

2. Now start drawing in portrait format with wax crayons on watercolour cartridge paper: first colour the petals in light red, leaving out the receptacle where it joins the stalk. Indicate the green parts of the plant with gentle strokes where they intersect with the flowers. Hatch in the darker areas gently with dark red, working with the direction of the shape. Apply soft hatching in maroon on the darkest areas.

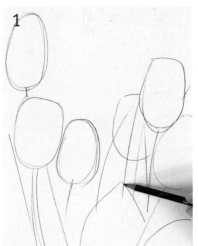

3. Rapidly apply water with the brush. Use rapid strokes over the individual flower parts, but do not paint, otherwise the lines will disappear! Allow the flowers to dry.

4. Draw the leaves and stems in May green. Add details such as leaf veins and shadows. Apply patches of shadow with blue-green. Only draw the darkest areas with strong strokes; for the rest, use gentle hatching. Be careful, because blue-green is a very dominating colour!

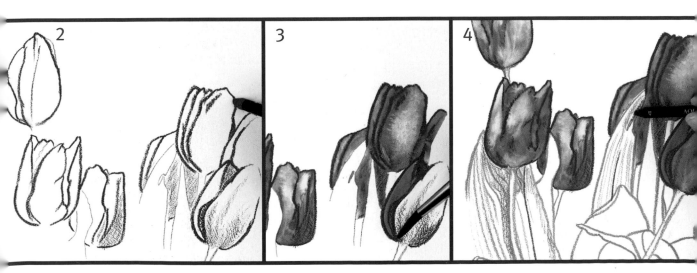

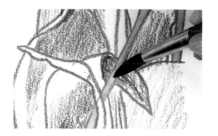

Tip: Paint over the stems and the narrow leaves first, since these are the lightest green areas.

5. Go over the remaining green parts with the wet brush (see the tip on the left). Use the smallest possible number of strokes on individual parts of the drawing – do not paint over them, just dampen them! Move the brush as little as possible, otherwise the lines will be smudged. Let it dry and then paint on the receptacle in light yellow with strong pressure. Create a gentle transition down to the stem (see detail below). Stipple arched shapes upwards into the red petals. Hatch the flowers following the shape in reddish-orange, leaving out the lightest parts. Add some strong red accents to the hatching.

6. Draw the shadows on the flowers with dark red crayon: these are mainly the places where the petals touch each other. Hatch all the leaves using May green, leaving out most of the stems, but stipple the stems on the right side of the picture. Give the second stem from the right a narrow line of shadow on the right side.
Go over the dark green areas with blue-green crayon. The areas in question are mainly beneath the flower heads on the left and the large leaves on the right.

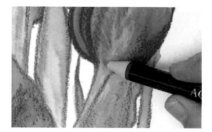

Detail: Rendering the shape in yellow and red gives the receptacle form.

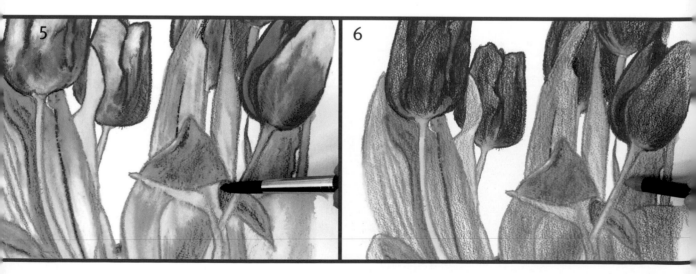

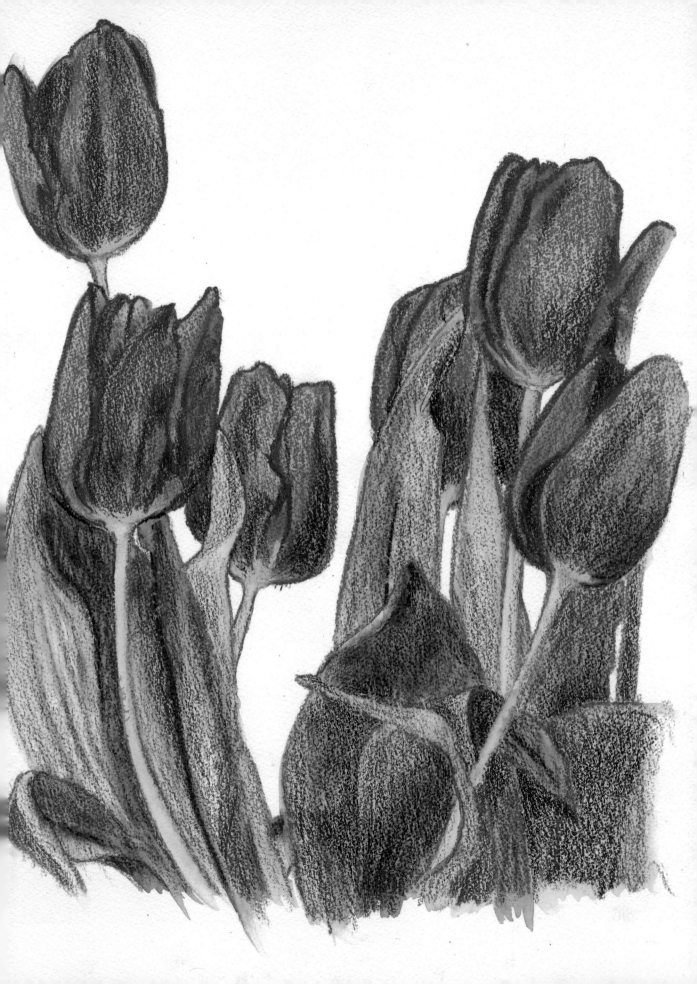

Apple blossom

Apple trees bear countless bright flowers in the spring sunshine. You can create a feeling of light in a pencil drawing by placing strong shadows among the flower formations.

Bud

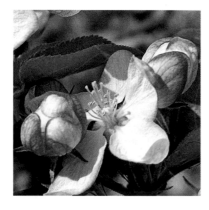

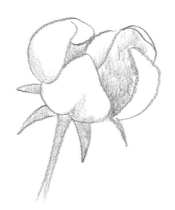

When the bud opens, the petals have a strongly concave shape. As they unfold they become flatter.

Blossom

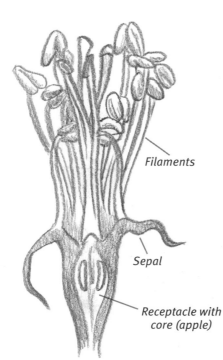

Filaments

Sepal

Receptacle with
core (apple)

A cross-section makes the structure of the interior clearer: there are five sepals on the receptacle, surrounding numerous filaments.

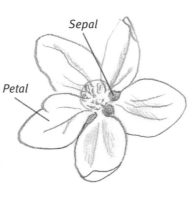

Sepal

Petal

Five bowl-shaped petals surround the centre of the flower. Each petal narrows down towards the centre of the flower. The underlying sepals shimmer in the gaps between the petals.

Blossom on branch

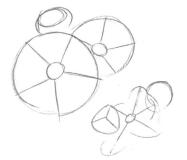

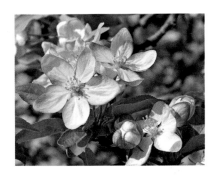

It is easy to turn blossoms and buds into simple geometric forms. The open blossoms form a circle subdivided into five segments on the branch in the photograph. The buds have basically oval or rounded forms.

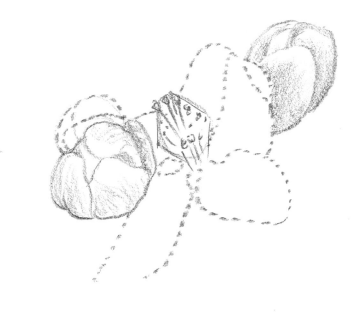

It is often difficult to distinguish separate buds and blossoms. Note: when shapes with the same colouring lie in front of or behind the drawn object (dotted line), the whole blurs into a single shape.

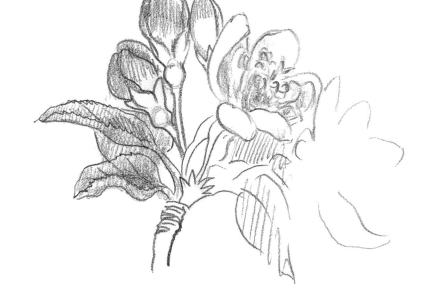

The blossoms on the branch form groups like umbrellas. The leaves have a serrated edge. Give areas of shadow more depth by adding finer and finer hatching.

Drawing project

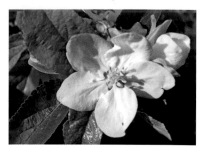

Materials: A3 drawing paper (190g/m²), 5B pencil, kneadable eraser, paper stomp or blending stick

1. Draw the centre of the flower and the petals of the large blossom. Show the folds in the petals. Draw the anthers and filaments, and shade these. Detail the outlines of the petals. Shade the gaps between the petals. Note that they are not all equally dark. Sketch in the remaining blossoms, the bud and one section of the leaves in the background.

2. View the subject with your eyes half closed, so you can add in the shadows on the large blossom and the spherical blossom on the right. Hold your sharpened pencil very flat for this. Go lightly over the paper.

3. Draw and shade in the remaining elements of the picture. The foliage is very dark: the large blossom is clearly delineated thanks to the contrast of light and dark. Shade in the fine corners with a normal grip on the pencil, rather than a broad grip.

4. Check all the light areas with half-closed eyes. Erase any superfluous lines from the initial drawing with the kneadable eraser. Close up the tones on the foliage by working them with the paper stomp or blending stick. Compare the shadows on the photograph with those on your drawing. Increase the shading where necessary.

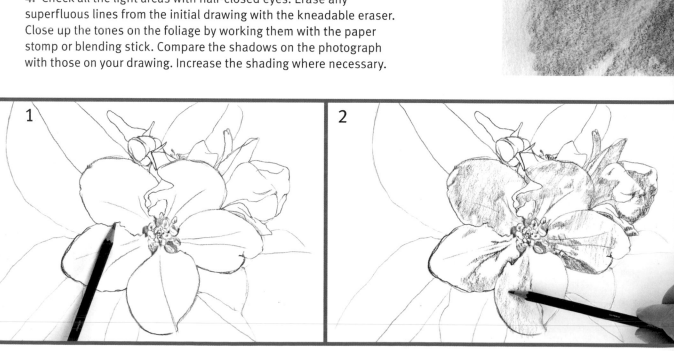

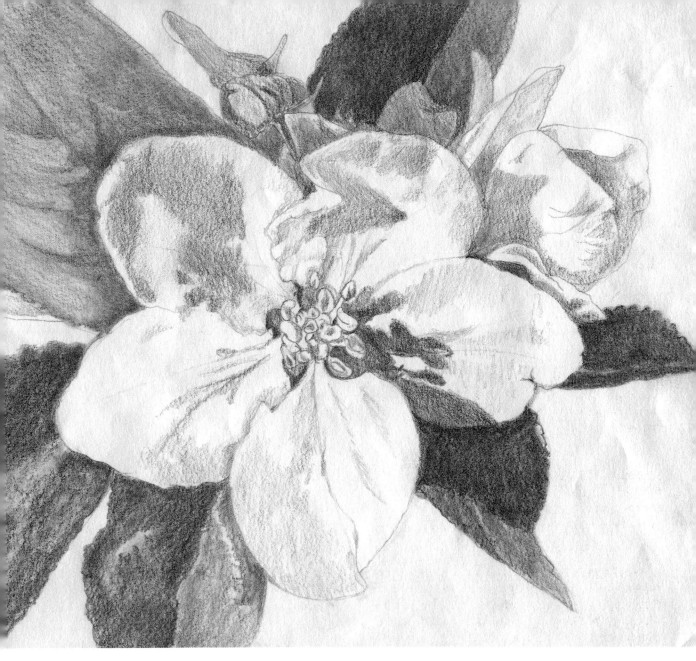

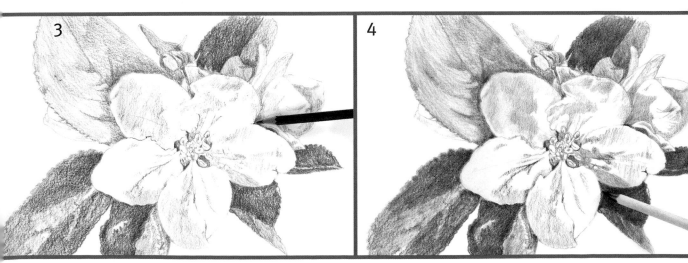

Dandelion

Dandelions are wonderfully easy to draw. It is easiest to work on a coloured background for dark dandelion 'clocks', densely packed with seed heads, with little white star-shaped 'parachutes' above them. Chalk pastels will emphasise the plant's delicate structure.

Flower structure

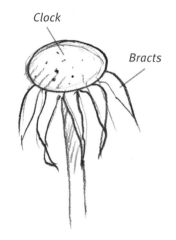

Clock

Bracts

The long, powerful, straight stalk of the dandelion carries a rounded head, the so-called 'clock'. The bracts, which previously enclosed the bud, now dangle like small, pointy twisted banners under the clock.

Little parachutes

from below at an angle

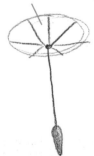

from above

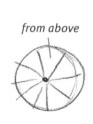

from the side

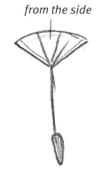

The brown seed hangs by a thread from the parachute (or pappus). The parachute is round. When we view this at an angle it looks oval. From the side it is wedge shaped.

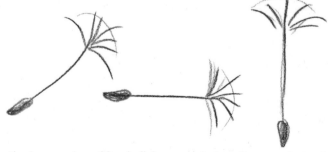

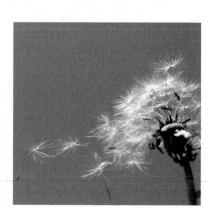

To give the impression of freely flying parachutes, the parachutes in the picture must not be distributed too evenly. The direction is also important. Diagonals give the best impression of movement. Verticals appear static, while horizontals seem to be at rest.

Drawing project

Materials: *ice-blue pastel paper (160g/m², size 35 × 45cm (14 × 18in),
HB pencil, ruler, kitchen knife, fixative*
Pastel chalks: *May green, black, burnt sienna, white*

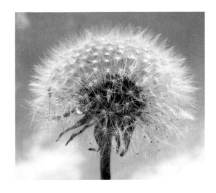

1. On the rougher side of the paper, use a pencil and ruler to draw a frame some 2cm (1in) wide all the way around. You are going to draw within this picture frame; you can remove it later on. Draw a large dandelion with rapid white chalk strokes, some echoing spheres and some flying parachutes. Mark the centres of the spheres. Indicate the stalks, clocks and bracts in black.

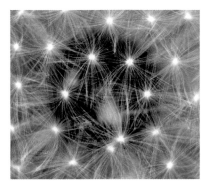

2. Place some white markings for the small parachutes on the main flower, which you can represent as a circle. Around the edges make wider and denser strokes, with those in the middle fewer and shorter.

3. Draw the black seeds on the main flower clock. Some of the threads on the seeds can be extended outwards. Define the points of the bracts in black. Give the flying parachutes white threads and black seeds.

TIp: You can vary the composition of the dandelion design in whichever way you like. If you feel the area beneath the parachutes is still too empty, you can draw more flowers in greater detail. The picture should above all communicate lightness – so be sure not to overdo it! If the parachutes 'fly' from left to right in the usual reading direction, this gives a very strong feeling of movement.

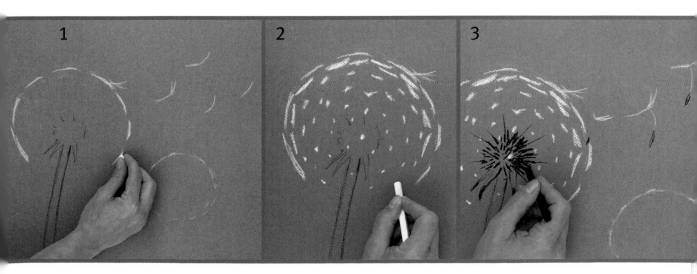

4. Smudge the black centre of the main flower with your finger. Add fixative to the centre, then draw white parachutes over the entire sphere: viewed from the side, these appear as little stars in the middle, and the rest are drawn at an angle.

5. Smudge the white of the little parachutes carefully with your finger. This makes the dandelion look denser. Draw a couple of individual parachutes at the top of the sphere, as if they are about to fly off.

6. Colour the stem and the points of the bracts first with burnt sienna, then work over them with May green. Darken the bracts and the right side of the stem in black. Emphasise the left side of the stem in white.

7. Work on the flying parachutes with white chalk. The whitest part is the centre of the parachute. Highlight the seeds attached to the parachutes in white and then work over them in black, so that the chalks mix.

8. Apply some white chalk dust on to the other flowers with a knife. Rub the colour in a circle with your finger. Shake or blow off the excess chalk.

9. Draw some black dandelion clocks on the other flowers, and then smudge these. Indicate white contours, but render one of the spheres more clearly than the others. Draw some little stars there as well. Remove the outer pencil frame and fix the entire picture.

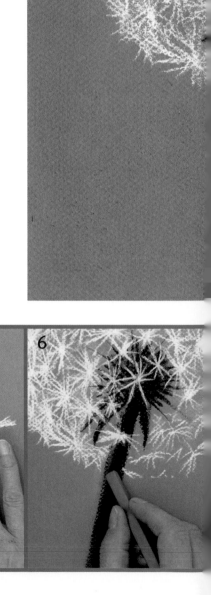

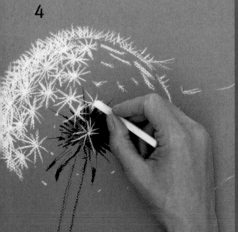

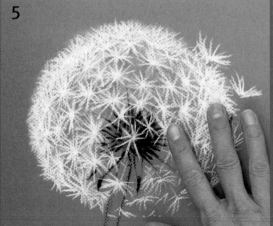

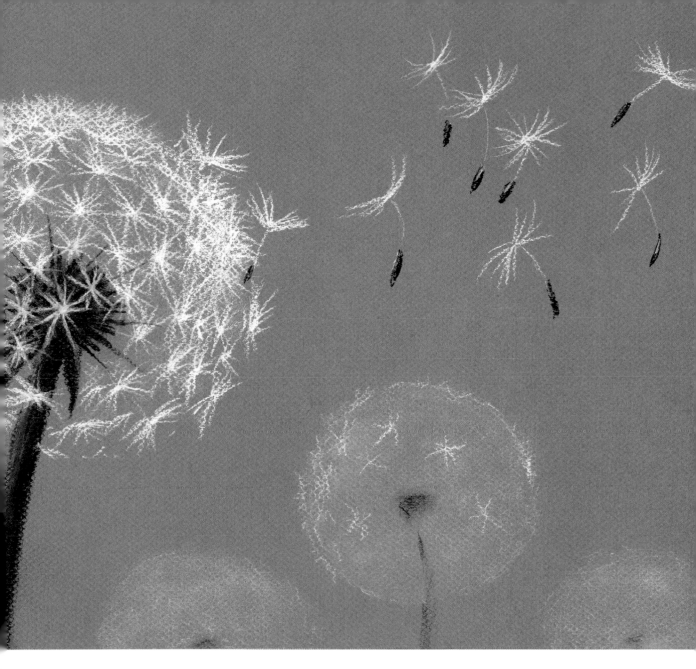

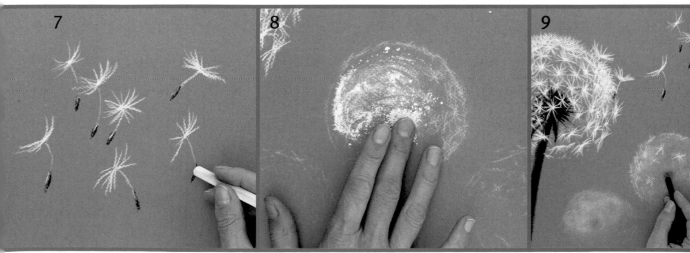

Narcissi

In the case of narcissi we see that the more oblique the angle of view is, the more interesting the picture becomes. Unfortunately the perspective is difficult for beginners. Make things easier when you start out by first drawing the flowers from the front or from the side.

Views of flowers

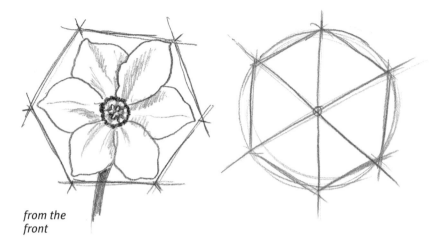

from the front

The narcissus bloom has six petals. The corona or trumpet in the centre of the flower encloses the pistil and the filaments. When seen from the front, the basic shape of the bloom is a circle. It turns into a hexagon if we divide the circle to indicate the petals.

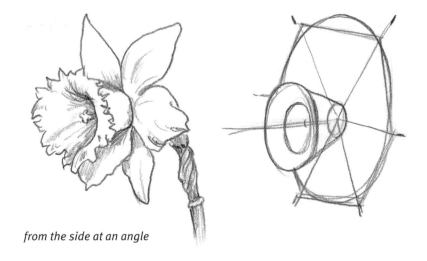

from the side at an angle

The bloom becomes an oval when we view it in half-profile. The corona can protrude less or more depending on the type of narcissus. In the case of this daffodil, it resembles a trumpet, whose opening again forms two ovals. There is an axis going through the crown to the receptacle (base of the flower). This marks the position of the stamen, around which the filaments are grouped in a circle.

The basic circle again becomes an oval if we view the bloom at an angle from below. Note: the six-fold division is not entirely symmetrical in this case! The central point of the corona or trumpet marks the start of an axis which continues into the stem. This axis determines the direction of the bloom. The corona here has the shape of a small bowl.

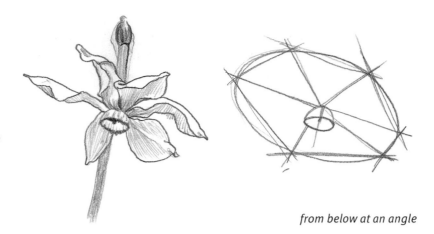

from below at an angle

The back of the flower shows how the stem is attached. Here we can see clearly that the petals merge into the stem. There is a papery sheath between the green receptacle and the stem. It is brownish and somewhat crinkly. The stem stops before the sheath in a clearly visible curved line.

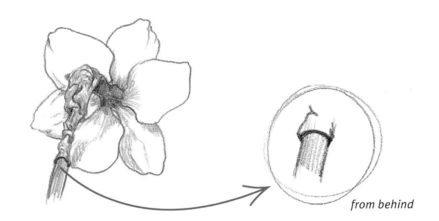

from behind

Bud

The bud emerges folded up out of the sheath. The tip is blunt and already displays an angular shape. We can see very clearly where the stem begins, and there is a strong line around the circular start of the sheath.
Very young buds are shaped like a narrow oval which ends in a point. In the drawing the small shadow on the point makes it clear that the inside of the bud is blunt in shape, unlike the covering.

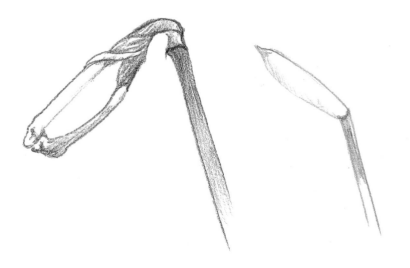

Leaves

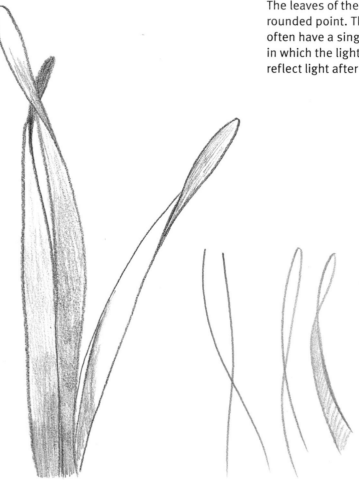

The leaves of the narcissus are long and narrow, with a rounded point. They grow fairly straight upwards, but often have a single twist to the side. This changes the way in which the light falls. A shadowy leaf surface will often reflect light after the rotation and will thus appear bright.

The basis for a narcissus leaf is two intersecting wavy lines. They need to be close to each other. Practise the curves, and then draw a rounded end at the top to connect the lines. Shade part of the drawing, and you have a recognisable leaf.

Light and shade

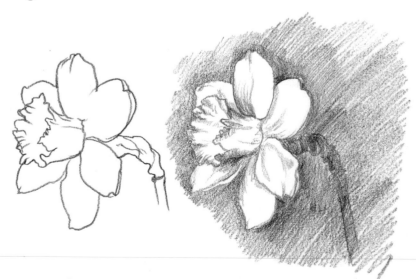

Flowers that are shown in a linear fashion have a flat appearance. Shading in different greys – the tonal values – gives depth to the drawing. A good way to view the bright and dark areas of a shape is to squint through half-closed eyes. Strongly contrasting light and dark tones create tension in a picture. Bright flowers glow more strongly when they appear in front of a shadowy background. You should lighten areas that have become too dark with a kneadable eraser.

Drawing project

Materials: bright yellow pastel paper (100g/m²) size 30 × 40 cm (12 × 16in), 4B graphite pencil, kneadable eraser, paper stomp or blending stick, soft cloth, fixative

1. Start by drawing the basic shapes of the bloom on the yellow pastel paper: the circular contours of the corona, the circular interior and the six large petals. For the moment we will not worry about the background and the leaves.

2. Develop the interior of the flower, which will later on become the darkest part of the narcissus. Shade around the filaments and the pistil. Draw the crinkles around the corona, while referring closely at your reference photograph.

3. Develop the shading in and around the trumpet. The uneven fringe is orange in a real narcissus. For this reason you should draw the fringe a little darker than the rest of the trumpet, which is yellow in the reference photograph.

4. Darken the interior of the bloom once more, and draw the transition to the shadows in the adjacent petals. Use your finger or paper stomp to smudge across the entire trumpet, giving it a unified form. If you happen to touch the large petals while smudging, remove the unwanted pencil marks with your kneadable eraser.

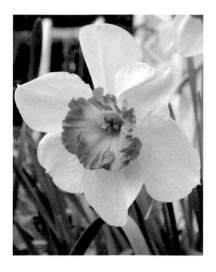

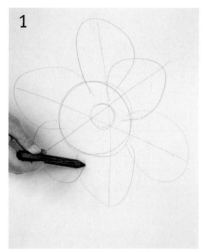

1

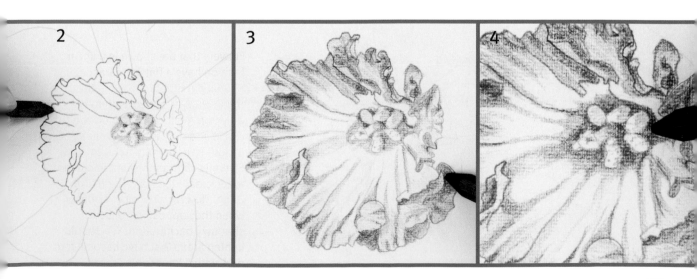

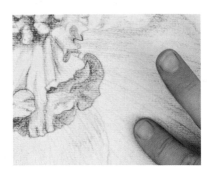

Detail: In order to define the bright areas as finely as possible, use a very fine point on your kneadable eraser, and keep on reshaping it.

5. Draw the precise outlines of the six large petals. Remove any superfluous lines from the initial drawing with the kneadable eraser. Indicate the soft shadows around the petals, by drawing fine lines following the contours of the petals. Do not use any pressure and keep the pencil flat. Carefully smudge the shadows on the large petals with your fingers (see the tip alongside for this).
Make a point with the end of the kneadable eraser. Squint through your eyelashes, so you can see the brighter parts in the reference photograph better, and then rub out the bright areas in the petals with the pointed kneadable eraser (see detail below left). Lighten lines that have become too heavy with the kneadable eraser.

6. Draw the narrow leaves using curved lines. Use available sketches to guide you – or else make up your own fantasy leaves! Follow through strongly on the leaf contours.

7. Shade the entire background, both above and below the leaves, with a broken-off graphite pencil or by holding a graphite pencil flat. Smudge the colour evenly with a soft cloth, to within a centimetre of the bloom. You can rub the graphite dust up to the petals themselves using the paper stomp. Be careful: you must not touch the flower! Shape the leaves with various shades of grey and highlights (refer to the finished drawing on the right). If you feel that the bright flowers need to stand out more, work over the background once more with soft, flat shading. Finally, fix the picture.

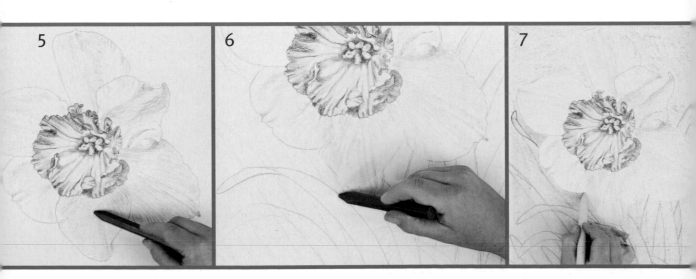

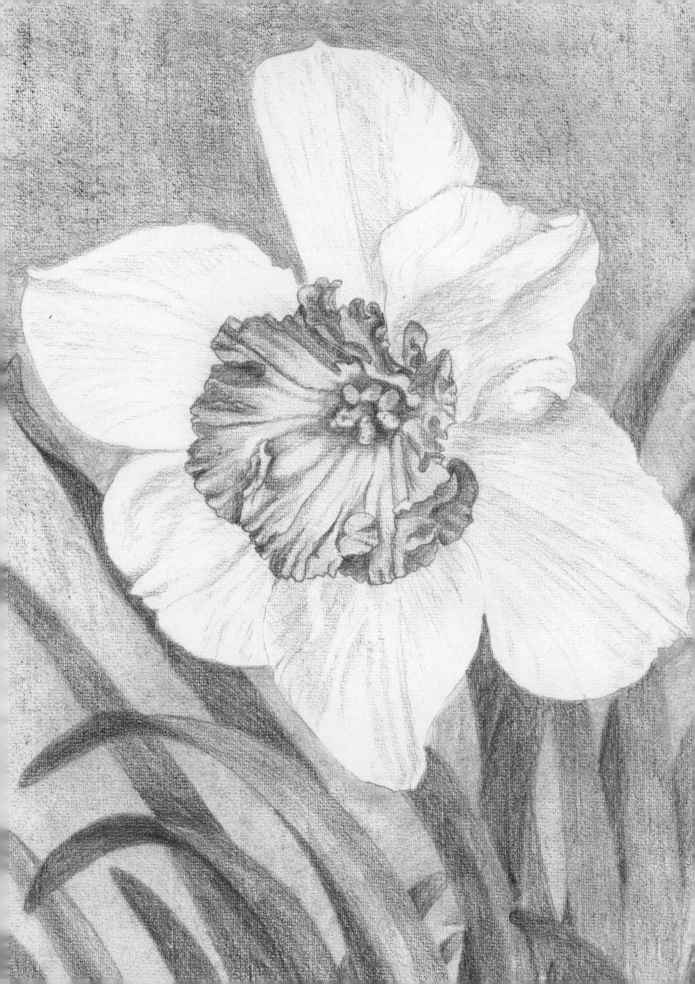

Poppy

With its glowing flowers, the poppy is an ideal subject for a colour drawing. The petals vary according to the genus of poppy, but they all have simple structures and decorative shapes.

Bud

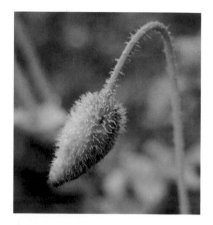 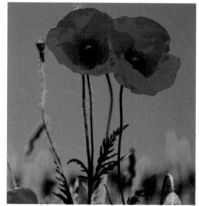

The poppy bud is bent down, with a thin stem. All the green parts of the poppy are covered in stiff little hairs, including the feathery leaves. Two strong boat-shaped sepals enclose the thin soft petals within the bud. When the flower blooms, the stem becomes erect and the sepals fall off.

Flower

Poppy blooms have four large petals with a crumpled texture. Try dissecting a poppy flower to appreciate the four-fold division. The basic shape of the petals is an oval, which evolves into a triangle towards the centre. The corn poppy has fire-red petals with a black patch at the base.

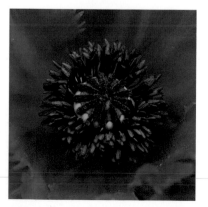

The dark purple stamens inside the flower surround the large ovary. It has a shield-shaped stigma with several hairy ridges. Viewed from a distance, the centre of the flower looks like a prominent dark eye.

Views of flowers

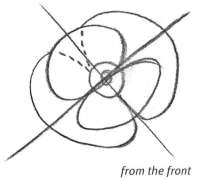

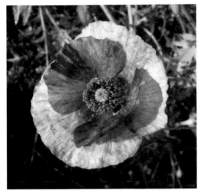

The open bloom of the corn poppy has four petals, which are arranged in a cross shape: one petal always overlaps the space between the other two.

from the front

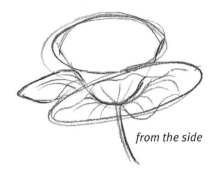

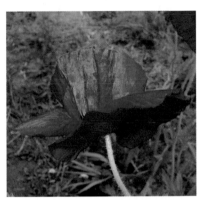

As the corn poppy ages the two outer petals open out further. They fall outwards, while the two inner petals remain bowl-shaped. The outer petals turn into long, narrow ovals when seen from the side.

from the side

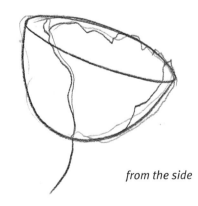

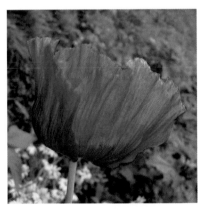

The young flower of the opium poppy is reminiscent of a tulip. The sketch uses the basic shape of a bowl, here with a narrow oval as the opening.

from the side

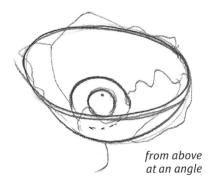

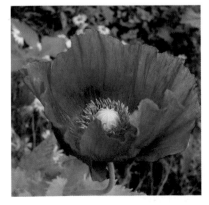

When it is in full bloom, the opium poppy keeps the form of a compact bowl, but in general the bowl becomes a little flatter. Seen at an angle from above, the aperture forms a wide oval.

*from above
at an angle*

Drawing project

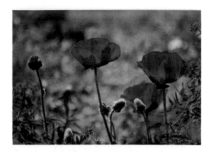

Materials: *A4 drawing paper (150g/m²)*
Colour pencils: *dark red, geranium red, earth green, cadmium orange, mauve, scarlet red, black, ultramarine, umber, walnut brown*

1. First make a rough sketch of the basic shapes of the plants. Draw some soft lines in cadmium orange and earth green and then add detail to the blossoms, buds and stem shapes in the same colours. Pay attention to the shapes: the corn poppy has a crumpled silhouette, for example. Draw the narrow leaves of the spurge to the side and colour everything in.

2. Work on the red parts with the scarlet red. Draw the creases in the flowers in straight lines. Draw the shadows caused by the backlighting as shapes. Work less on the lower poppy. It appears further back in the reference photograph and therefore needs to merge gently into the background. In this way the upper blossoms become more prominent. We call this technique focusing: the background becomes blurred, while the foreground is shown more clearly (see also the tip on the left).

Tip: *The further back an element appears in the background of a picture, the less detail you should apply.*

3. Draw the darkest areas of the flowers in black. You should carefully darken the stems with black as well. Work over the shadows on the blossoms with dark red and umber.

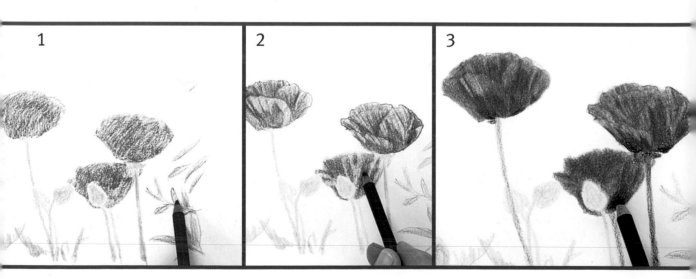

4. Reinforce all the green parts, leaving out the areas that are in the brightest sunlight. Darken the green with black. Apply dark areas in the background carefully in black. In this way you clearly emphasise light areas like the edges of the buds at the bottom of the picture.

5. Draw over the flowers, following the creases with geranium red, in order to intensify the colour (see detail on the right). Apply cadmium orange over all the red tones, to intensify the colour. Finish the plants at the side of the picture with cadmium orange: here you can draw narrow leaves and umbrella-shaped flower surfaces.

6. Shade large patches in mauve in the background (see tip on the right). You can also work over strongly coloured areas with ultramarine. Fill in the areas between the mauve patches with shading in earth green. To merge the background colours, draw lightly across the edge of some patches, including the shapes of the background flowers. Be careful: to ensure that the foreground plants remain distinct, you should not draw over the edges of their flowers, buds or stems!

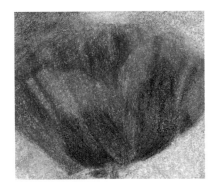

Detail: Bring out the creases by drawing over them strongly.

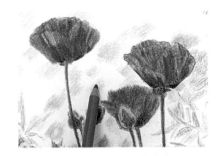

Tip: When shading the mauve patches in the background, cross-hatch with irregular, gentle movements while holding the pencil flat.

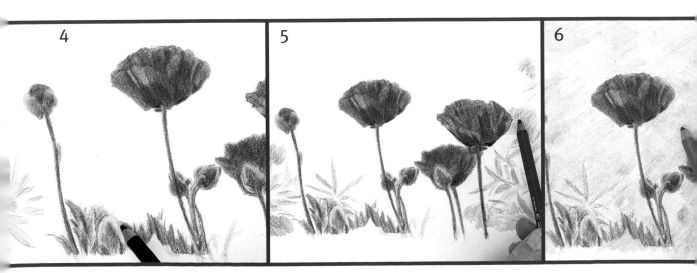

7. Define dark areas in the background with walnut brown. Go right up to the edge of the left poppy. Leave a light border around buds and stems.

8. Intensify the dark areas with more mauve. Draw over the mauve patches with a mixture of mauve and ultramarine in order to vary the colours. Mixed tones will make a picture fundamentally more lively.

9. Draw in black, cadmium orange and earth green over the spurge at the edges of the picture. Develop some narrow leaves and jagged points along the lower edge. Darken the areas in between the leaves, as well as the background. Intensify the colours of the poppies and the buds by drawing over them with cadmium orange. Because cadmium orange is relatively light, it will not cover the other colours, but only make them denser.

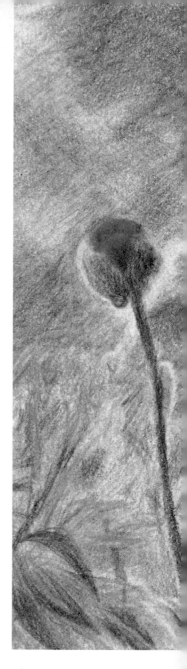

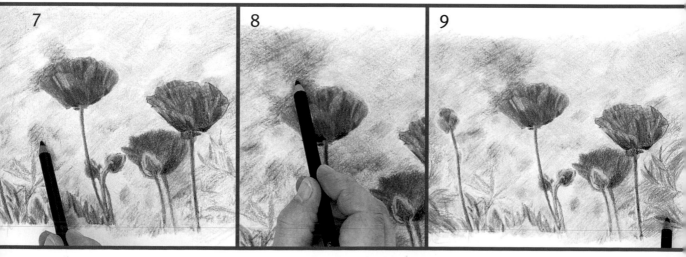

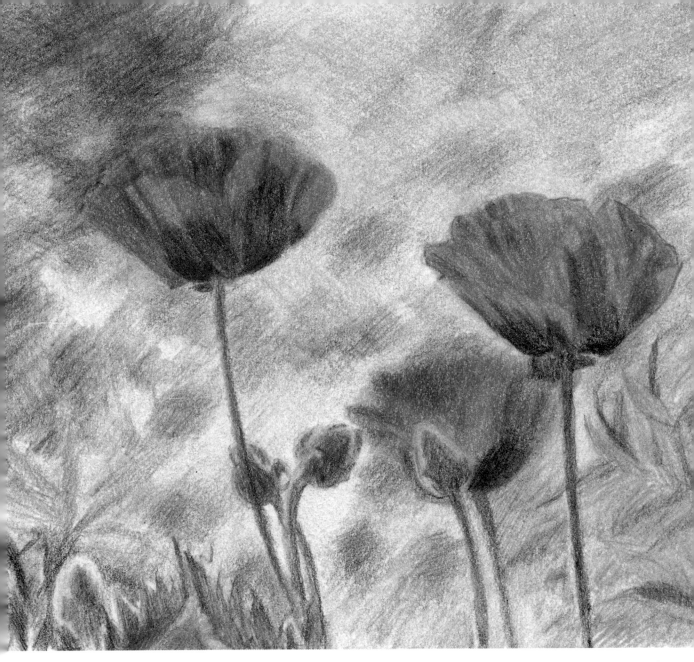

The strong, dominating red of the poppies will be absorbed into the orange background shapes and thus harmoniously toned down. The curved stem of the central bud gives the drawing depth.

Cow parsley

When covered in hoarfrost, cow parsley resembles the skeleton of a plant and is made into a prominent motif. Good for beginners: winter umbels are easy to draw, because they have no blossoms or seeds.

Plant

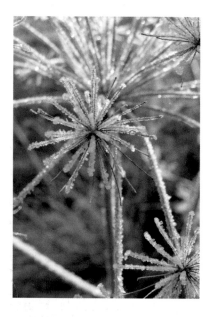

Cow parsley has stiff stems with a somewhat grooved surface. Numerous stalks radiate from a single point at the end of the stem and create an umbrella-shaped flower cluster or umbel. The stalks of the umbel carry more, smaller umbels. This type of flower is termed a 'composite umbel'.

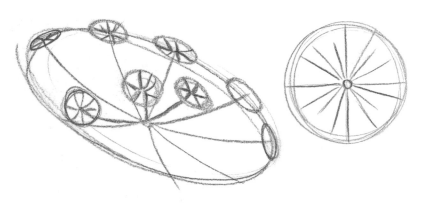

The basic shapes will help you to build up the picture: first make a light initial drawing of the outline of a large umbel as a circle or oval. You can then sketch the smaller umbels as fine rounded shapes, and then connect their centres to the point in the middle at the end of the stalk.

Do not draw all the umbels as a basic circle but try to angle them realistically. Compare each one with a straight edge, for example your pencil, to help angle them correctly.

Views of flower clusters (umbels)

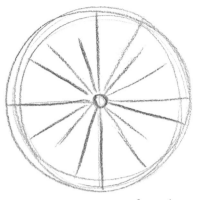

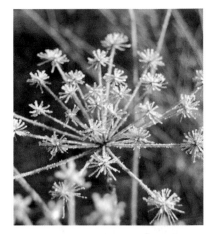

When seen from above, the basic shape of an umbel is a circle. The stalks radiate like a star from the centre of the circle. They appear to have different lengths, because of the foreshortening effect when seen from above.

from above

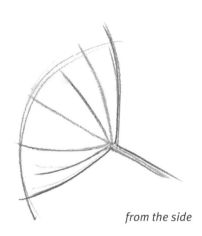

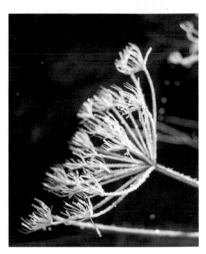

From the side view one can simplify the umbel to a 120° arc. Pay attention to the gentle curve of the stalks – this gives more variety than simple straight lines! Some of the stalks are, again, foreshortened.

from the side

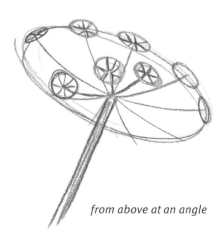

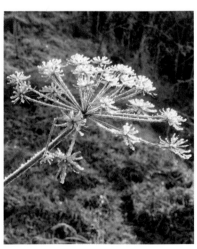

Seen at an angle from above, the umbel outline becomes an oval. The centre shifts downwards. The circular forms of some of the small umbels also turn into ovals – depending on whether you view them directly from above or from the side.

from above at an angle

Drawing project

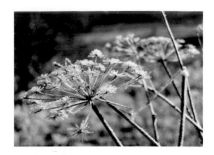

Tip: Shaved bits of colour can be smudged with your finger or, in the case of this project, with a brush.

Materials: white drawing paper, ice-blue pastel paper (160g/m²) size 35 × 45cm (14 × 18in), brushes (no.4 and no.12), 4B pencil, putty eraser, kitchen knife, sandpaper, fixative
Pastel chalks: Prussian blue, walnut brown, white

1. First prepare some rapid pencil sketches on drawing paper. These will help you to position and determine the relative sizes later on.

2. Take the blue pastel paper. Shave some Prussian blue chalk dust with the knife on to the area above the centre (see the tip on the left). Smudge the blue chalk dust with a no.12 brush into a wide stripe. Distribute white chalk crumbs all over the remainder of the paper. Smudge the white across the paper's width above the blue stripe. Indicate grass stalks in the lower half of the picture with vertical and angled brushstrokes.

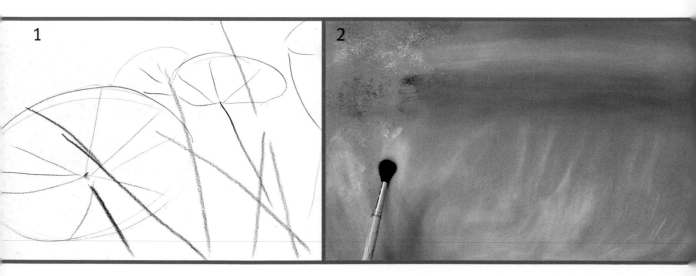

3. Draw some strands of grass on the left in white. Place some umbel-like scribbles and irregular patches in Prussian blue in the bottom right half of the picture. Smudge everything with the thick brush. Apply a thin layer of fixative spray over the white-blue background.

4. Add brown to the fresh white and blue colours to give the picture a little more warmth. Add umbels and stalks in walnut brown (see tip on the right). Start with gentle sketching. Check the effect by standing back from the picture and only then draw the plants in greater detail.

5. Apply some white above or to the right of the brown lines. This needs to look like hoarfrost settling on the stalk, while the underside remains dark. On the fine lines of the small umbels, this is difficult to achieve accurately, so apply white accents to create the impression of frost.

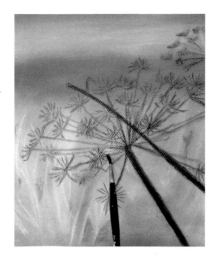

Tip: Smudge the brown strokes with a fine brush.

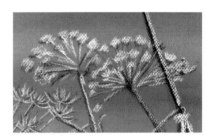

Detail: White accents on the fine umbels create the impression of hoarfrost.

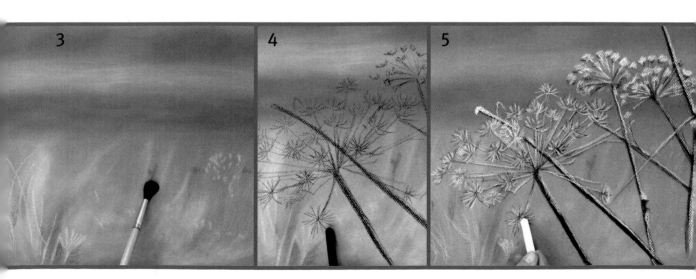

6. Smudge the white chalk strokes with the fine no.4 brush. Fix the drawing at this interim stage.

7. Bring into focus the left umbel and stalk, which crosses the picture diagonally. To do this, add dots over the white lines with the sharp edge of a white chalk. If necessary sharpen the chalk using some sandpaper. Emphasise the stalks and umbels in the foreground to create depth. The stalks and umbels further to the right need to be pushed into the background. Go over the lines on the right only lightly (also see tip below). Finally fix the picture.

Tip: To ensure that the stalks remain in the background, only apply the white very sparingly.

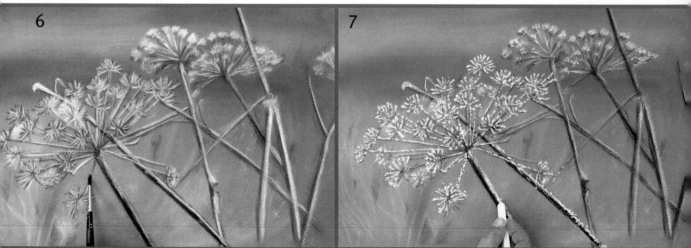

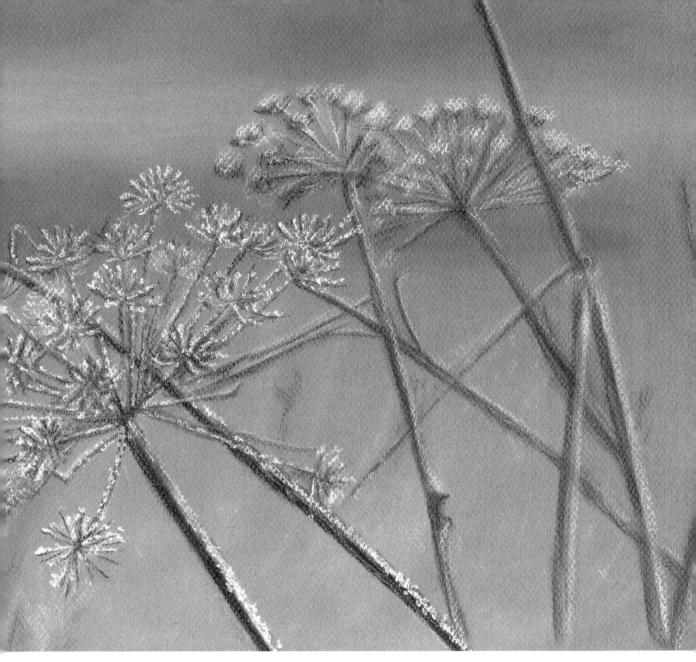

The direction of light, from the the front to the back of the picture, emphasises the filigree structure of the cow parsley. It is not only the hoarfrost, but also the diffused blue in the background, that communicates a wintry feeling.

Gerbera

The gerbera has numerous small, outwardly curved 'ray florets'. The colour palette ranges from white through yellow, orange and pink to red. It is a challenge to draw the curves in the petals correctly in perspective – but it is worth the effort.

Flower structure

The saucer-like end of the stalk is the flower receptacle. On top of this are numerous tubular florets. The receptacle is surrounded by pointed sepals, which are superimposed like scales. The long petals (ray florets) emerge between the tubular florets in the centre and the sepals.

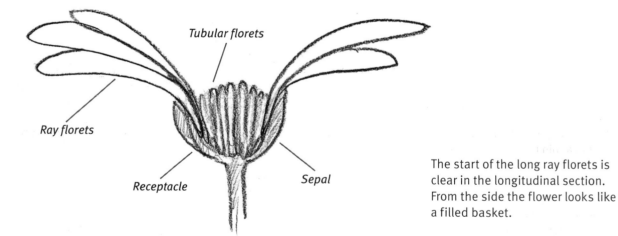

Tubular florets

Ray florets

Receptacle

Sepal

The start of the long ray florets is clear in the longitudinal section. From the side the flower looks like a filled basket.

Basic form

From an angled viewpoint the whole flower can be seen as an oval, the middle of which is somewhat shifted out of place by the perspective. Draw a right-angled cross in the oval. This creates segments in the flower. Subdivide the segments again to make smaller slices.

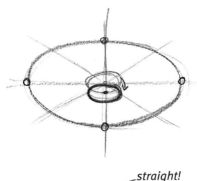

straight!

The vertical line in the basic form represents an imaginary axis for the ray florets. Draw the long ovals for the petals straight on to the base oval. All the other petals gently curve outwards.

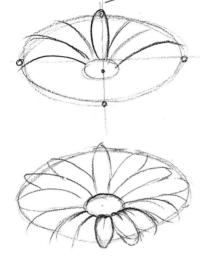

Taking this viewpoint, you can see the transition between the receptacle and the rear ray florets clearly, but in the case of the front ray florets the transition is obscured.

Petals

You can compare a gerbera ray floret to a thin board. From above it looks like a long rectangle, while from the side it is almost just a stripe. Its shape changes according to the perspective. The same applies to the petals – except that they are also grooved and curved! The best way of practising is to acquire a living flower and then draw as many views of it as possible.

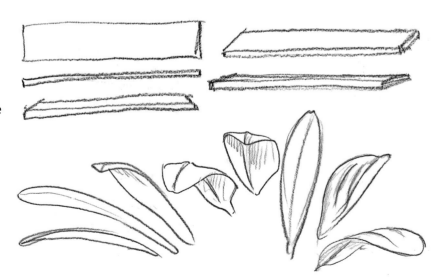

Views of flowers

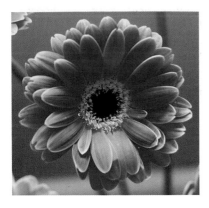

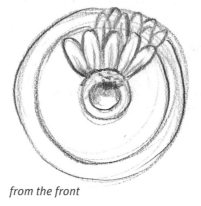

from the front

When seen from the front, the basic shape of the bloom is a circle. The centre of the flower and the receptacle are also circular. The petals are grouped in rings around the centre with the tubular florets.

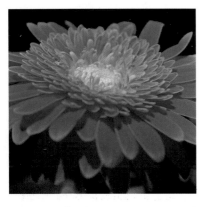

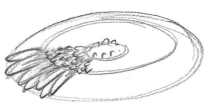

from above at an angle

The flower has oval basic shapes when seen from an angled viewpoint. This type of gerbera also has a variety of large ray florets: very small petals surround the centre in four rings and outside these are two to three rows of larger ray florets extending outwards.

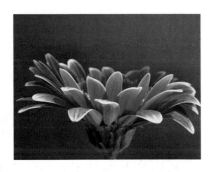

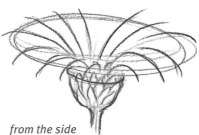

from the side

Seen in profile the flower has outwardly curved petals, and it is easy to see the scaly sepals underneath. The contours of the petals and the sepals are drawn as ovals from this view.

Drawing project

Materials: A4 white and lavender-blue pastel paper (160g/m²), kneadable eraser, soft brush, cutting surface, cutter, sticky tape, fixative
Pastel chalks: viridian, cadmium yellow, cadmium orange, light ochre, May green, mauve, scarlet red, burnt sienna, straw yellow, walnut brown

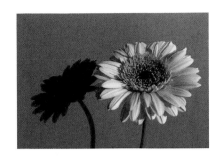

1. Start by drawing the abstract shape of the flowers on the lavender-blue pastel paper in a diagonal form. Indicate the dark centre with burnt sienna and the outer contours in straw yellow. Make scarlet red rings around the centre. Draw the inner rings in cadmium orange, and extend the ray-shaped lines outwards.

2. Draw the shadow of the gerbera in pencil on white paper. Cut out the shadow shape on the cutting surface with the cutter (see note on the right) and discard. Position the template with sticky tape on the lavender-blue paper, taking care to overlap it with the bright edge of the flower oval. Repeatedly apply mauve within the template and push the coloured chalk with your fingers into the jagged edges of the shadow. Wipe the image with the soft brush and remove the template. Use the kneadable eraser to carefully remove chalk from the places that have been accidentally coloured. Fix the picture before moving on to the next stage.

3. Add the stalk of the flower in May green, but leave space for the ray florets. The left side of the stem is in shadow, so darken it with viridian. Draw long, ochre-coloured ray florets in a circle around the reddish centre of the flower.

Note: When creating the shadow template, pay attention to the correct dimensions relative to the flower.

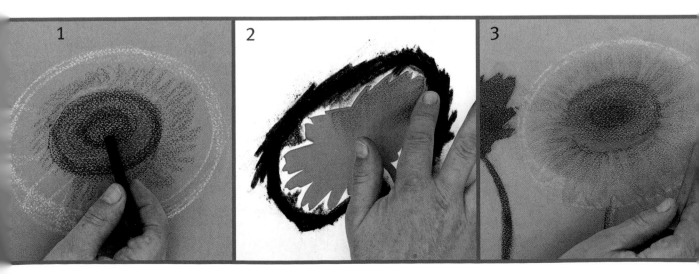

4. Fill in the ray florets with cadmium yellow. Smudge the colour with your finger. After getting rid of unwanted marks with the kneadable eraser, add fixative to the picture at this interim stage.

5. Apply bright patches to the long ray florets with straw yellow. The small ray florets in the orange-coloured area should be drawn as small pointed arches in cadmium yellow.

6. Draw the small curves of the inner petals with cadmium yellow. Apply some orange chalk to the bases of the long ray florets.

7. Enhance the edges of the small inner petals with straw yellow. Add straw yellow points as highlights in the dark centre of the flower. Add more walnut brown dots in the centre.

8. Finally, work over the entire flower in straw yellow. Curve some yellow tubular florets in hook shapes towards the brown centre, and highlight some more ray florets. Check your work: are there any bright or dark patches missing? Are there any smudged areas left? When everything is in order, fix the picture.

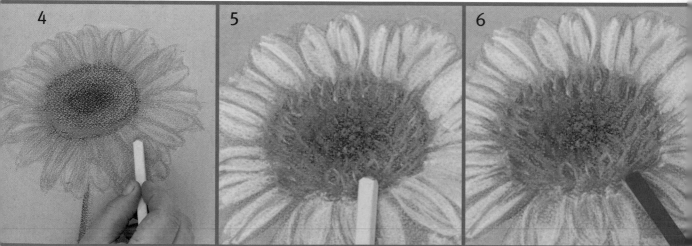

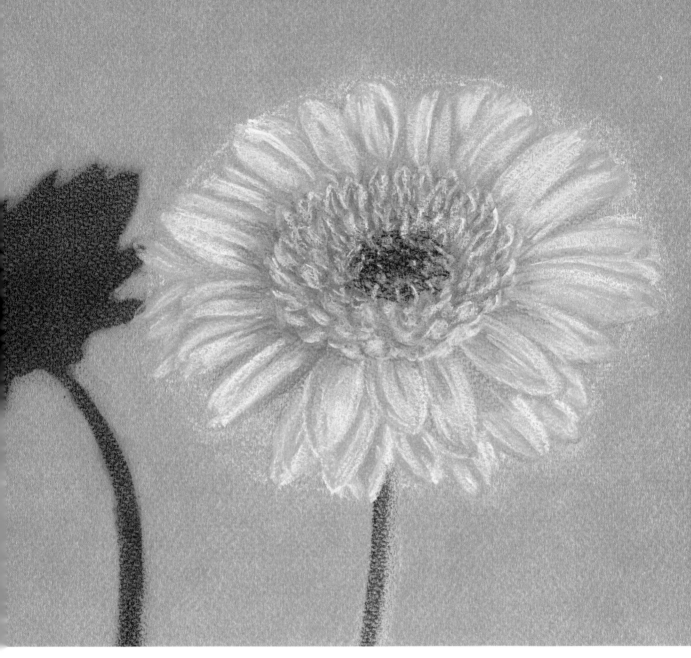

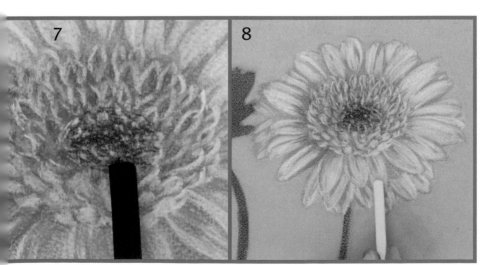

The luxuriant glory of the petals unfolds before the pastel-coloured background, while the contrast-rich shadow generates depth.

Calla lily

The calla lily has a simple but elegant form and is therefore extremely suitable as a beginner's design. The white bloom looks particularly bright when placed in front of a dark background. You can create this kind of contrast very easily with charcoal.

Flower

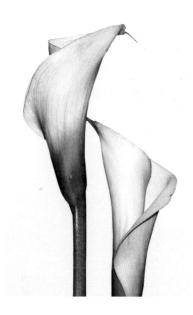 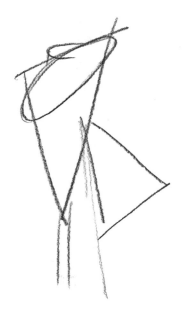

The bright, turning leaf blade is characteristic of the calla lily. It gradually turns green towards the base of the flower and is coloured as it merges into the stem. The outlines of the leaf blade have a narrow or wide triangular shape depending on its position. The opening at the top, however, is an oval.

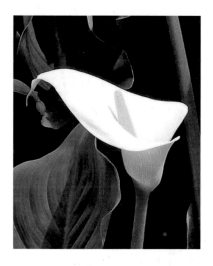

The true flowers of the calla lily are situated on the egg-yolk yellow, spike-like 'spadix' in the funnel of the leaf blade. The spadix is in the centre of the basic triangular shape in the simplified drawing. It is an extension of the thick, leafless stem.

Leaves

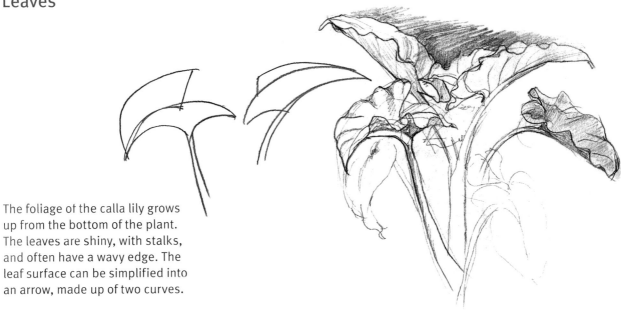

The foliage of the calla lily grows up from the bottom of the plant. The leaves are shiny, with stalks, and often have a wavy edge. The leaf surface can be simplified into an arrow, made up of two curves.

Flower sketches

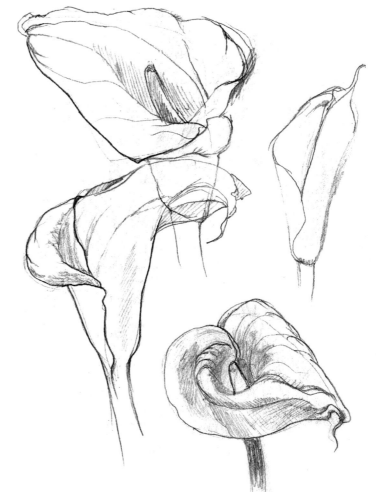

There are two motifs on top of each other in these less detailed sketches. Sometimes there is not enough room for individual sketches in a small sketchbook. Do not be afraid to make sketches that overlap each other. The results are still clear enough. It is striking here that the leaf blade of the calla lily ends in a little 'tail'. The bud has a narrow, rolled-up form.

Drawing project

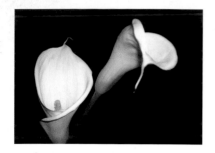

Materials: *A3 drawing paper and pastel paper (130g/m²), charcoal pencil, 6B pencil, kneadable eraser, paper stomp or blending stick, fixative*

1. First prepare some pencil sketches on drawing paper. Try to capture roughly the basic shapes of the blooms. Because the lower right corner in the illustration looks empty, you will need to add some more flowers. The sketch at the bottom of page 69 is an example. Take the charcoal pencil in your hand and make a preparatory drawing of the flowers on pastel paper. Keep comparing the shapes with your sketches. Indicate the shadow areas faintly.

2. Develop the shading by following the contours of the three-dimensional shapes. Smudge the lines and surfaces with the paper stomp or blending stick. Apply gentle strokes on all three blooms in a lengthways direction, and then work on them with the paper stomp or blending stick.

3. Hatch in the background with the charcoal pencil. Go over this with the paper stomp. Blend right up to the edge of the flowers, and gently into the stems. Cover irregularities with a second layer of hatching, and then smudge this again. Use the kneadable eraser to remove unwanted marks or to reduce lines that have become too strong. Finally fix the picture.

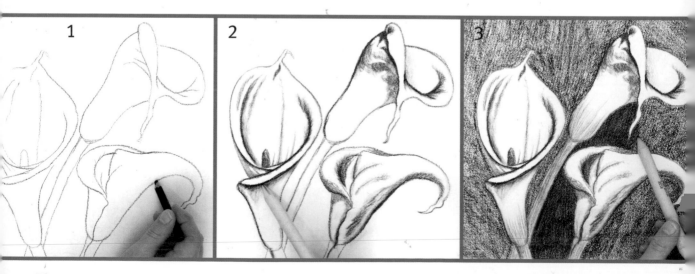

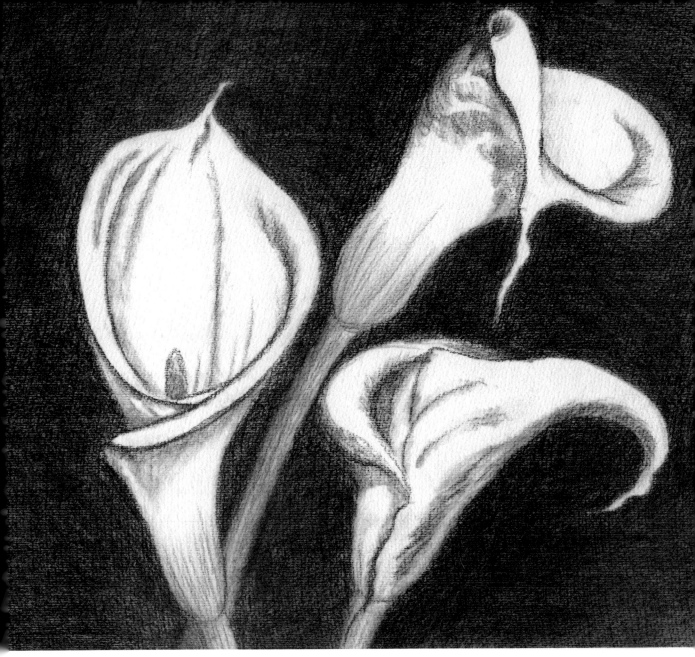

The spiral-shaped flower tips and the finely developed shadows give both depth and life to the picture.

Dahlia

You could hardly wish for more beautiful and varied flowers. Drawing dahlias correctly is quite challenging. There are lots of petals that break out of the basic geometrical design. This gives movement and life to the image.

Bud

A dahlia bud is a solid ball crowned with a cap made from the sepals. The bud shimmers yellowish-green. When the bud opens, the petals curve outwards, and the flower's colour becomes visible.

Petals

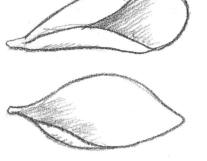

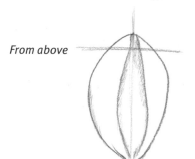

Central groove

From above

Central groove

Cross-section

The dahlia's petals are rolled at the sides – some more so than others. They start from a narrow base at the receptacle. You can picture a single petal as an upturned spoon with a groove in the middle.

Flower shapes

A simple flowering dahlia has eight petals and a symmetrical structure. The centre of the flower is built up from several circles. Groups of four oval petals are arranged in two cross shapes. They overlap on alternate sides.

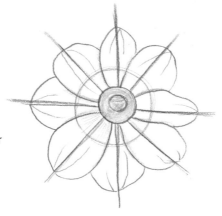 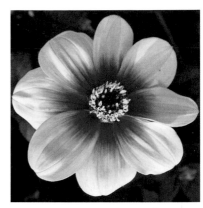

A decorative dahlia has a compact centre, reminiscent of a bud. The narrow petals here are densely packed, overlap each other strongly and form a ball. The external petals sit in a circle around the centre of the ball, sometimes in two rows.

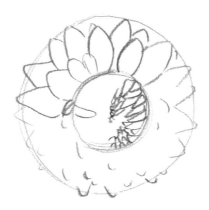 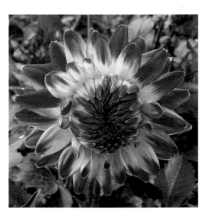

The longer petals wrap the egg-shaped centre in thick layers in this dahlia. There is a wreath of exterior petals around the foot of this vertical egg shape, and they seem to dance around the middle.

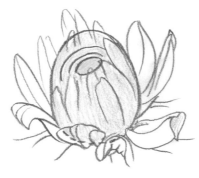 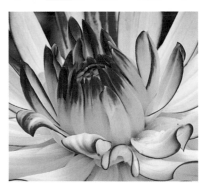

The ruffled dahlia has wavy petals around the centre of the flower like a collar. These petals are often on top of each other and contrast with the other colours. The tubular florets in the centre form a closed pattern of almost square elements.

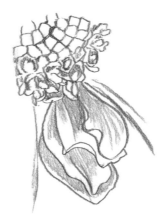 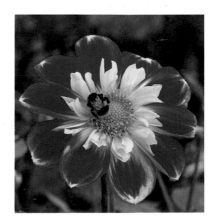

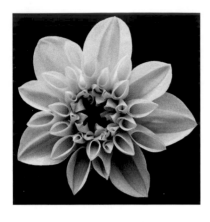

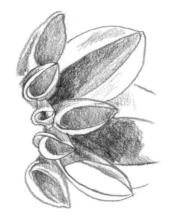

This yellow decorative dahlia exhibits various petal shapes: large and open at the edge, with rolled-up petals in the middle, and curved petals in the centre. The central point is in shadow and looks particularly dark when set off against the bright colours of the petals.

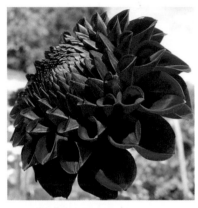

This luxuriant decorative dahlia has an unusually regular structure. The bloom is oriented towards the left in this angled perspective. The petals are arranged in regular rings around its spherical centre.

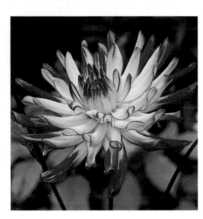

from the side

from in front at an angle

The tubular petals are reversed in the case of the cactus dahlia (sketch below) – not at all easy to draw. The blood-red edge, a special feature of this bloom, makes it easier to make out the contours. The schematic sketch shows the oval tube of the petal from two different points of view. The centre line and the end of the tube are marked in pink in the sketch here.

Drawing project

Materials: *soft green pastel paper (130g/m²) size 48 × 66cm (19 × 26in), no.12 paintbrush, kneadable eraser, fixative, cutter, cutting surface*
Pastels: *magenta, rose madder, manganese violet, black, sky blue, white*

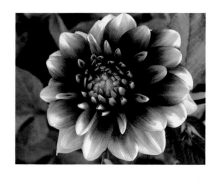

Exercise

Do some exercises before you start on this complex project, by drawing several details of a real dahlia. Most of all you need to sketch the petals!

Also practise the structure of our subject: show the outline and ball-shaped centre of the flower in the photograph as concentric circles. Divide up the circles with a cross and then draw just the petals that touch the cross (A).

You can then add the remaining petals (B). Keep comparing their direction with the circles and the cross. Is the petal at the same angle as the crossbars? Is it touching the central circle? Does it intersect the outer circle? Draw the centre of the flower last.

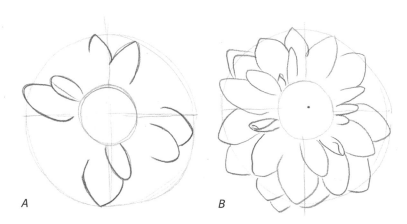

A　　　　　　　*B*

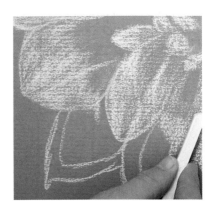

Detail: First draw the outline, then hatch softly, holding the pastel flat.

1. Squint so that you can see the brighter parts in the reference photograph better. Use the paper in portrait format, and draw in the bright areas in white (see detail on the left). Remember: the flower is essentially an outer ruff and a spherical centre. The centre is slightly shifted to the left due to the angled perspective. As a result there are more petals on the right-hand side.

2. Draw within the white areas with magenta. The chalks will mix (to a certain degree) in the process. Smudge the colour from the outside to the inside with your fingers (see tip below). Fix this intermediate stage and allow the picture to dry.

3. View the reference photograph with your eyes half closed to see the dark areas better. Create dark areas on your picture with manganese violet.

Tip: When rubbing, carefully use your fingertips; do not use your entire hand.

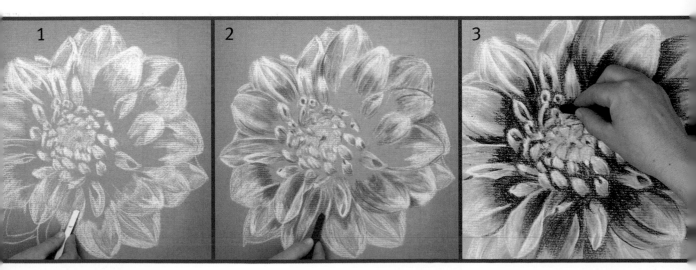

4. Work over the dark areas in black, and then smudge the black chalk with your fingers. Fix the picture and allow it to dry. Squint through your half-closed eyes before you sketch the bright areas of the background. Use the white chalk for this. Draw the dark areas in the background with light strokes in black (see detail on the right).

5. Hatch the large background areas as evenly as possible with black chalk.

6. Smudge the black you applied in the background with the brush. Remove unwanted chalk with the kneadable eraser, especially next to the bright buds on the lower right and the stem beneath the bloom (see tip below).

Detail: Use gentle black strokes for the leaves in the background.

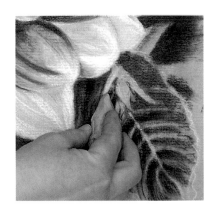

Tip: Make a pointed wedge from your kneadable eraser if you want to remove colour.

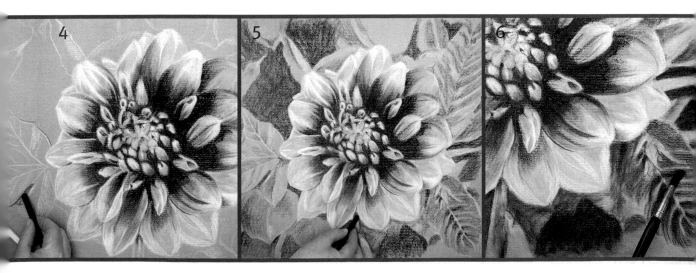

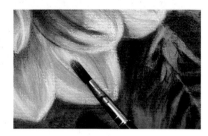

Tip: *The smudged white stripes look more attractive if you follow the direction of the lines when working with the dry brush.*

7. Draw very fine lines in the white petal areas with magenta. You can then create the shadows for the white areas with sky blue.

8. Work on the petals in white, magenta and rose madder. Be sure to reproduce the shapes precisely. Smudge the colour transitions with the brush. Note: be sure to preserve the outlines!

9. View the most important highlights in the reference photograph with your eyes half closed. Apply white in your picture for the highlights. Rub the chalk a little with the brush (see tip). Finally, fix the picture and cut it with the cutter to make a square of 40 × 40cm (16 × 16in).

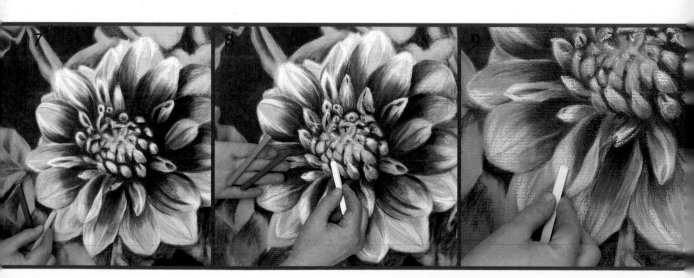

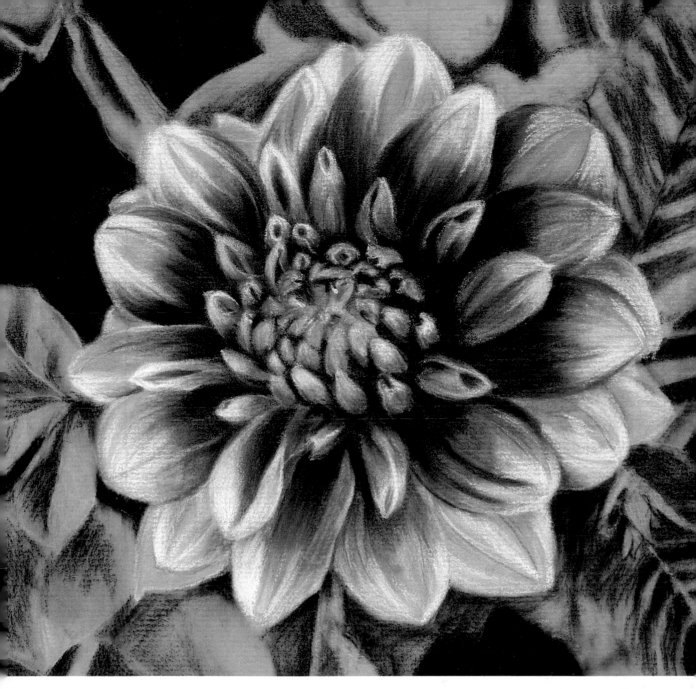

The strong contrast between white and black gives the flower a pronounced depth. The beauty of the flower is seen at its best when combined with violet and on a green-black background.

Honeysuckle

This climbing plant is also called woodbine. It has attractive, unusually shaped flowers. Trying to study the bends and shadows in a precise pencil drawing is a worthwhile project.

Buds and leaves

The claw-like pink buds of the honeysuckle bend towards the light. It is useful to think of these as long tubes when drawing them. The upper leaf pair has fused into a kind of plate shape, which is attached directly to the stalk without a stem. The other leaves grow in pairs opposite one another and have an oval shape. From late summer the plant bears red, pea-sized berries at the site of the flower.

Flowers

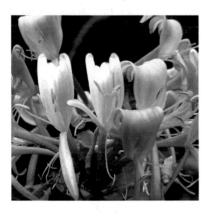

Once the buds have burst, the creamy white stamens and the style will protrude from the jaws of the flower. One flower-head bears up to twelve trumpet-shaped flowers. The petals are yellowish white and coloured red at the back. The flowers give off a sweet, beguiling perfume, particularly in the evening, which gives the plant its name.

Drawing project

Materials: *A4 drawing paper (150g/m²), 6B pencil, kneadable eraser*
Colour pencils: *light yellow, purple-pink*

1. Draw the entire flower mass using gentle pencil lines. Omit the background visible in the reference photograph. Only draw the two front leaves from the photograph – those which are attached to the stem of the flower formation. First work on the left flower-head: gradually shade the turned-up form of the large petal, going from dark to light. Draw a fine line like a shadow beneath the filaments. The lightly turned anthers have a groove, which is not clearly visible in every light. The ovary is almost invisible; its position is indicated by some small shadows where it meets the stem. Add a dark edge to the tongue-shaped hanging petal.

2. Shade the tubular buds. Begin with the dark tonal values. Leave bright spots paper-white and draw the intermediate tones last.

3. Develop the right-hand flower-head. Proceed exactly as with the left-hand blossom: shade the large petal, and accentuate the stamens. Add a dark edge to the long hanging petal as well. The shadowy areas need to be dropped in sparingly and accurately.

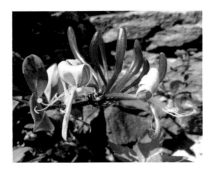

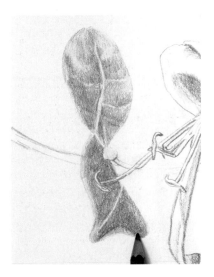

Tip: *You need to think very carefully about their structure in advance if you are going to draw leaf veins as bright negative shapes. You could keep a positive sketch of the veins next to you as you work.*

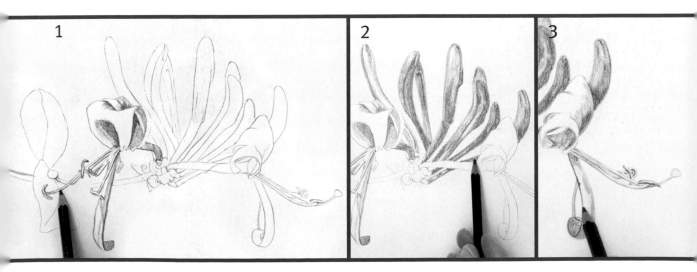

4. Draw the dark berries. You also need to shade the bases of the flowers and the bases of the tubular buds which radiate from them. Draw a small shadow in the form of a cuff at the base of the right-hand bloom.

5. Apply a soft grey tone to the surfaces of both leaves. Note: the leaf veins have to remain light (see tip on page 81). Carefully finish darkening the shadowy leaf areas. Draw the stem in three steps. Draw the left part only faintly and add a shadow under it. Shade the middle slightly less faintly and apply dark flecks over it. The right-hand section will be darker, because it is in the shadow of the bloom. Leave a light stripe on the upper part.

6. Check the contrasts and contours in the drawing once more. Where the light/dark contrasts appear to be too harsh, such as on the edging of the tongue-shaped petal, remove some colour with the kneadable eraser. Draw over the outlines of the tubular flowers until they appear closed. Finish by adding colour with coloured crayons, mainly working over the bright surfaces of the petals in light yellow. You can also draw over darker areas, but be careful: always make each stroke in the same direction as the previous drawing, otherwise the soft pencil underneath will be smeared. You can go over the tube-shaped flower bases and buds in the same way as the flowers, but with purple-pink.

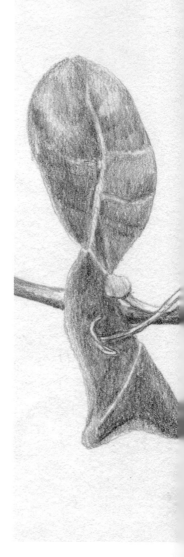

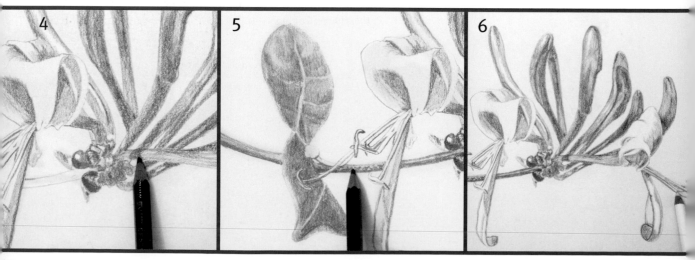

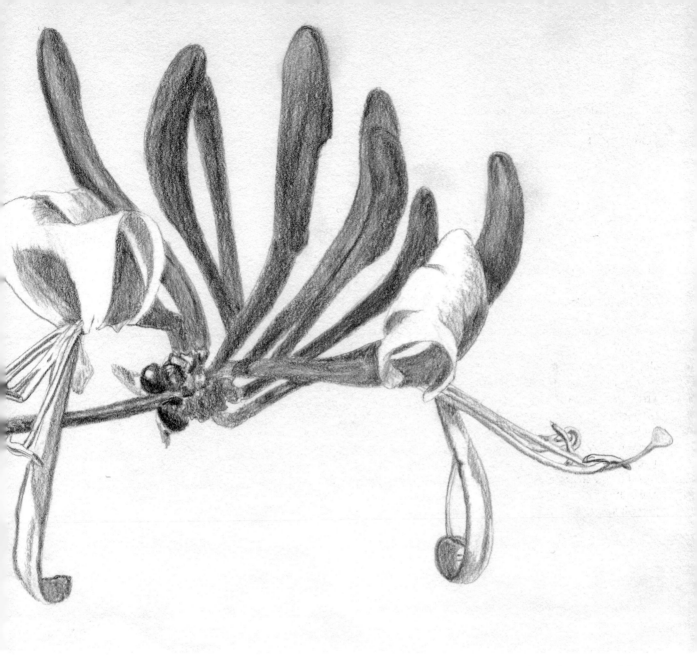

You do not need very much detailing thanks to the variety of shapes in this flower. You only need to colour the pencil drawing at the end.

Clematis

In the case of the clematis it is a good idea to pay attention to other parts of the plant as well as the superb flowers. The buds, leaves and winding stems are also attractive subjects for your sketchbook. Clematis makes a particularly good picture series.

Shoots and leaves

Two shoots grow at right angles from the main stem. Further shoots grow from this cross shape towards the light, the so-called axillary shoots. They then form buds and leaves. The leaves are constantly looking for somewhere to rest. In the process the stalks may create unusual bends and kinks.

Bud

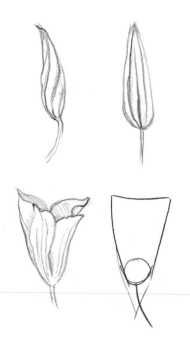

The clematis bud has a longish form with brownish violet striations. These striped divisions continue to be visible on the top and, most of all, on the underside of the petals. The stripes will then appear light in colour.

The bud looks like a cup that spreads out as it opens. In a simplified form you can draw an inverted triangle rounded off at the base, with a cross as the receptacle.

Flower

A clematis with four petals can easily be reduced to a simple basic shape. The circumference of the flower can be shown with a circle. The petals take on a cross shape. A small circle marks the centre of the flower in the middle of the cross.

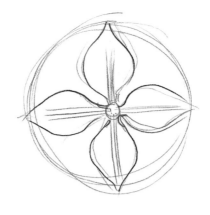

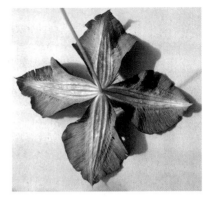

The basic shape of the petal is very clear if you dissect the flower; here it is a diamond with flattened ends.

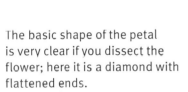

Stamens

The stamens surround the brush-like stigma in the centre. At the start of the flowering season the stamens are tightly closed and form an oval, but later they bend outwards like a star. The stamens are somewhat curved, becoming flatter the further they are from the centre.

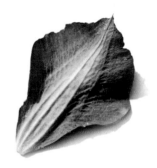

Through breeding, some types of clematis have developed stamens that are very long and numerous. In these types, the centre of the flower is bullet shaped.

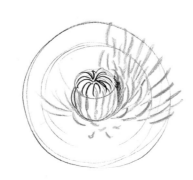

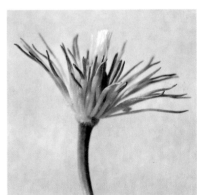

85

Flower shapes

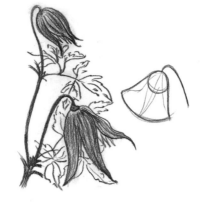

This *Clematis alpina* variety has eight pointed petals. The stamens are surrounded by numerous small sepals. The bud is oval-shaped, while the open flower has an attractive curved bell form.

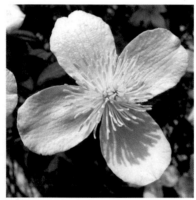

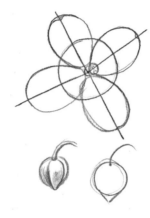

The bloom of *Clematis montana* has a symmetrical structure and bears four oval petals. The contour of the stamens forms a circle. The bud is almost round; there is only a small point on the basic rounded shape.

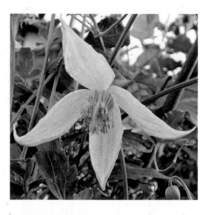

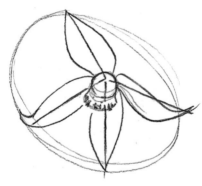

The bright yellow *Clematis orientalis* starts out like the base of a bell. The petals bend strongly outwards at the points. They surround the stamens, which in this species have the general shape of a cup.

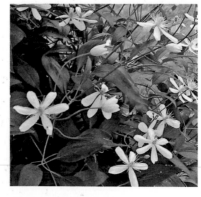

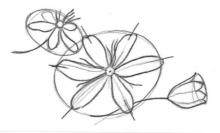

The young flowers of the *Clematis recta* have a tulip-like shape. The open white bloom is divided symmetrically into six. The flower has a very delicate appearance due to the narrow ovals of the petals and the very long stamens.

The superb red-violet hybrid 'Ernest Markham' bears six petals, each with three definite grooves. The flower itself is circular in shape. The stamens and the ball of the stigma form two more circles inside the bloom.

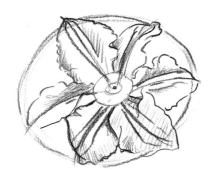 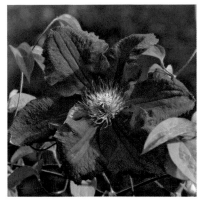

The flower of the clematis 'Dr. Ruppel' is not strictly symmetrical. The petals overlap sometimes on the right, sometimes on both sides, and sometimes on the left. Here I use thick lines to emphasise some of the petals.

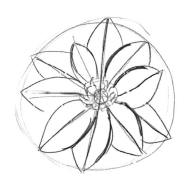 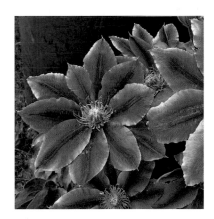

Perspective

If you view the flower from an angle, the overall round form looks like an oval.

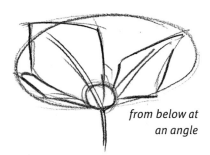 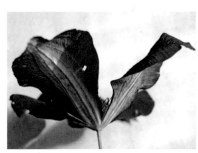

from below at an angle

Here is a side view of a flower with six petals. The basic form of the petals changes depending on the direction from which you look at them. From the side they are triangular, while seen from below at an angle they are distorted diamonds.

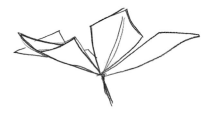 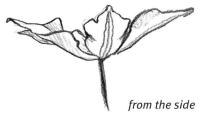

from the side

Studies

Branch *Stalk*

Four stalks extend in a cross shape from the main branch. Attached to this are leaves, a flower and two groups of fruit with long, feathery hairs. The stalk on the leaf winds tightly around a neighbouring stem.

Leaves

Clematis leaves mostly grow in groups of three. They often have small irregular indentations in the edges, which you can happily leave out when drawing; the most important point of studies is to capture the main shapes and lines.

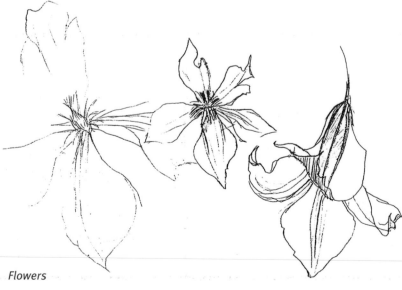

Flowers

The robust, simple form of a clematis has four petals. Occasionally you also come across examples with five petals. Draw both front and side views!

Drawing project

Materials: *handmade watercolour cartridge paper (300g/m²) size 17 × 24cm (7 × 9½in), watercolour brush (no.14), 4B pencil*
Watercolour pencils: *caput mortuum, viridian, cobalt green, mauve*

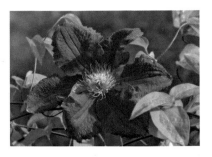

__Tip:__ You are strongly advised to do some prior studies from nature to be certain that you can draw a particular plant (see pages 84–88). You can use the results as references for your drawings, as I have done here. The reference for this clematis project are these three photographs, but so are parts of the drawings on the previous pages.

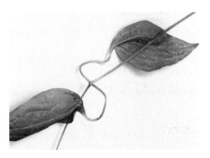

1. The clematis drawing project consists of three small drawings, which together form a decorative whole. Set out three sheets of watercolour cartridge paper and start by gently marking out an 11 × 11cm (4½ × 4½in) square on each one of them with a pencil. Make drawings of the motifs with a watercolour pencil inside the three pencilled frames. You will need mauve for the flowers, and viridian for the leaves and buds.

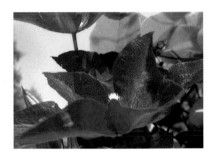

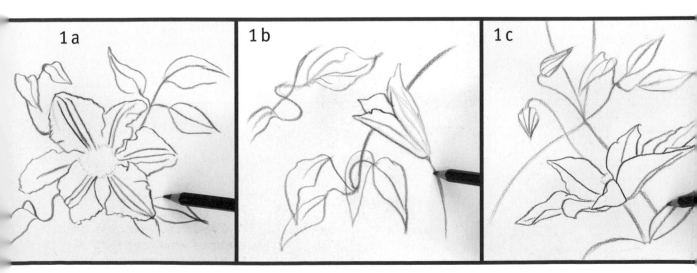

1 a

1 b

1 c

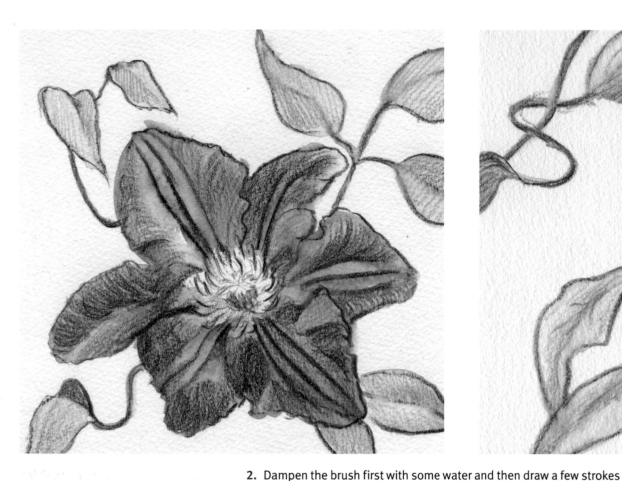

Tip: Draw fine curved lines as you develop the petals: the hatching will make the curves in the petal clearer.

2. Dampen the brush first with some water and then draw a few strokes over all three flowers. Under no circumstances should you just brush here and there or the drawing will disappear. After the flowers have dried, you can go over the stems, leaves and buds in the same way (2a). Hatch all the leaves using viridian and cobalt green (2b). Develop the buds and stems further using caput mortuum (2c). Hatch the petals with mauve, following the three-dimensional shapes (see tip below left). Finally work on the centres of the flowers. Indicate the star of the stigma gently in caput mortuum on the flower seen from the front. Draw a circle of stamens around it some distance away, then gently shade the centre of the flower on the left side with viridian (see tip below). Use only a few strokes to indicate the stamens on the flower seen from the side.

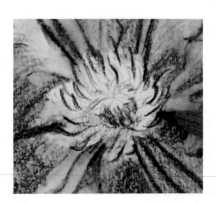

Tip: Use short, strong strokes to represent the thickened ends of the stamens.

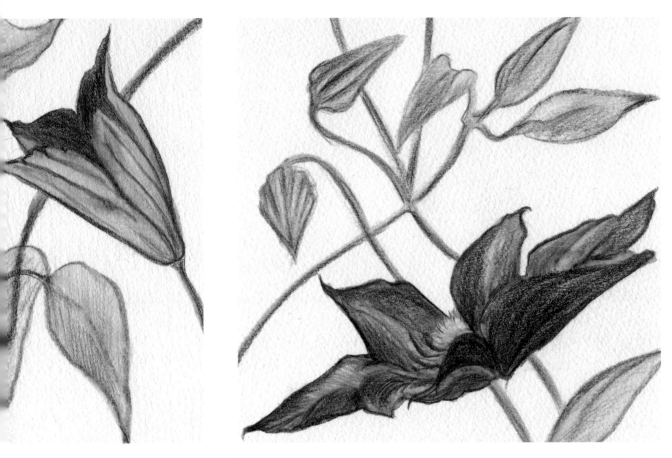

The bunches and flowers on the clematis provide plenty of variation. Every detail is a picture in itself. The three cut-outs are particularly effective as a triptych.

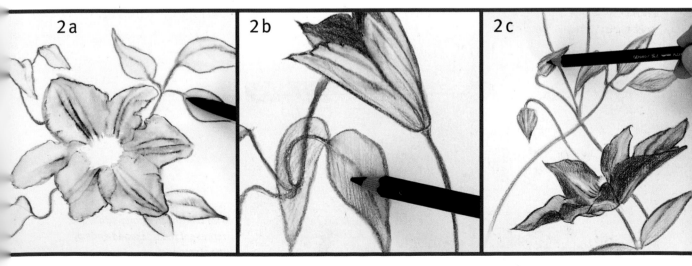

Physalis

There are two well-known species of physalis: one has edible fruits, and the other, known as Chinese lanterns, is used as autumn decorations. Both of these species have interesting calyces and are excellent subjects for creating colour pictures with orange hues.

Chinese lantern

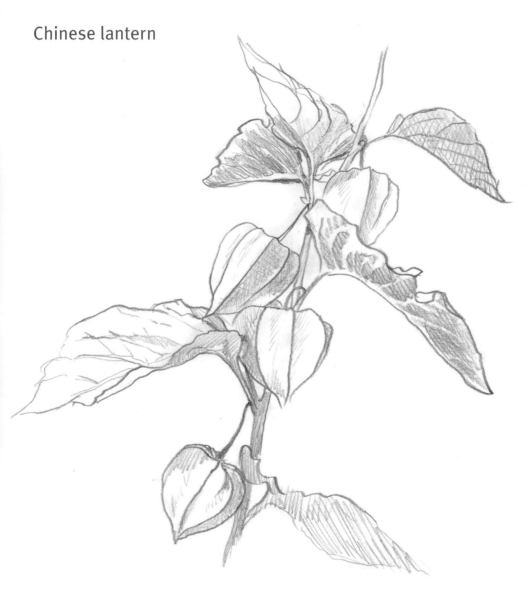

The leaves of the Chinese lantern end in a point and have distinct veins. If you have enough time, you can omit the veins and shade the areas in between them, thus creating a more attractive negative effect. Otherwise you can simply draw the veins with dark lines.

The lantern-shaped calyces appear when the plant ripens. They hide what will become the fruit. The small lanterns dangle from straight long stalks, which become narrower towards the plant. The colour of the stalk also changes towards the plant: red at the lantern end, but green at the plant end.

Basic shapes

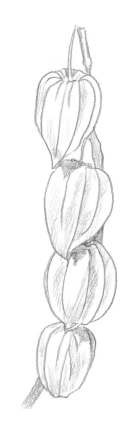

The lanterns are often densely packed. This creates many overlaps and shadows that make drawing them more difficult. You can bend the branch easily, as long as it is still fresh. The lanterns then hang separately, which makes it easier to see their basic shape.

Five exaggerated sepals enclose a small red berry in each lantern. As they ripen, the sepals change from a fresh green via yellow ochre to a bright orangey red. The veins are very prominent. From the side, the lantern has a teardrop shape.

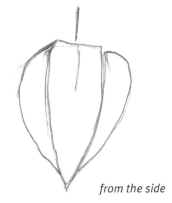

from the side

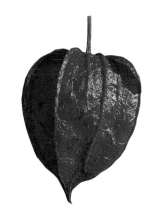

Viewing the lantern at an angle from beneath, it is easy to distinguish five sepal ends, which converge to a single point. The centre shifts downwards in this perspective and the simplified contour of the lantern appears to be a pentagon.

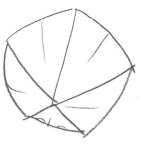

from below at an angle

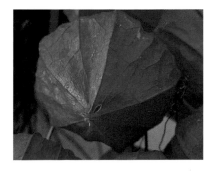

Cape gooseberry

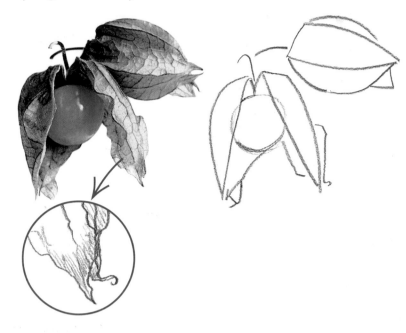

The sepals or calyx around the Cape gooseberry enclose an orange-coloured edible berry. The sepals open as they ripen and change colour from green to yellow ochre. The leaf veins become more and more distinct in the process. Practise drawing the basic shapes: the berry can be represented as a circle, the shell as triangular shapes converging to a point.

Line and rendering

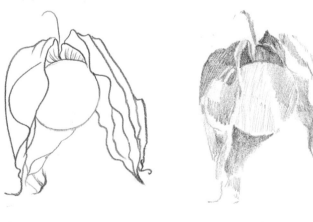

The sepals have wavy edges in the more accurate line drawing. The little stalk resembles a tiny walking stick, while the ends of the sepals are like fairy slippers (see also detail above). To distinguish between the bright and dark areas, first squint through half-closed eyes. You will then need to turn the tonal values into grey-scale tones. Use a very soft pencil to apply fine hatching.

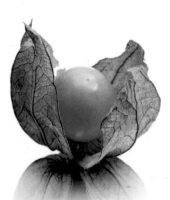 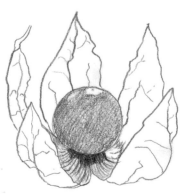

The base of the berry is easy to see if you open the sepals up a little. The berry sits in the middle of the bowl. The effect of the base of the sepals is to make it appear as though the fruit is being presented on a small stand. There is a strong shadow under the berry. The drawing combines lines with shading.

Drawing project

Materials: handmade watercolour cartridge paper (300g/m²) size 20 × 26cm (8 × 10in), brush (no.13), kitchen paper
Watercolour pencils: cadmium orange, cobalt green, light ochre, olive green, Prussian blue, burnt sienna, terracotta

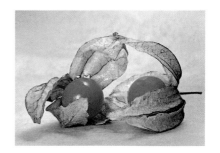

1. First draw the round silhouette of the berry in cadmium orange. Reduce the sepals to their basic shapes, using olive green. Do not apply much pressure during the entire initial drawing. Illustration 1 only has strong lines to make them easier to see.

2. Hatch the berries with cadmium orange, leaving out the light spot. Draw the veins and contours of the sepals strongly in olive green. Squint at the reference photograph so you can see the light and shadow in it better. Hatch the darker areas in the picture, while leaving out the light parts.
Moisten the brush with water. Make a few powerful strokes across the orange-coloured fruit (see tip on the right). Completely avoid the light areas. Allow the berries to dry. Paint over the leaves in the same way with water.

Tip: It is important to work decisively when you paint over the watercolour pencil hatching with the damp brush. Whatever you do, do not just brush here and there or the drawing will disappear.

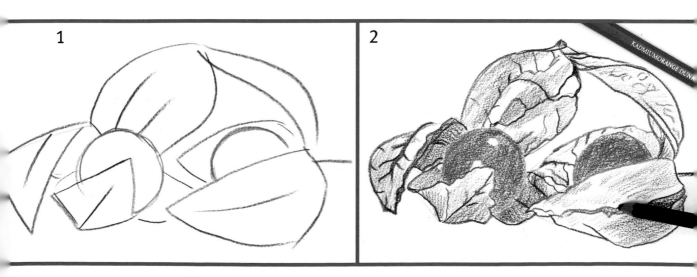

1

2

3. Go over the veins and dark shadows on the leaves strongly with cobalt green. This colour is dark enough for deep shadows. Work over the dark shadowy areas with light ochre. View the image with your eyes half closed; then work over the less dark areas you have identified. Only the light areas should not be reworked.

4. Gently paint over the light points on the berries in cadmium orange. Only on the left-hand fruit are there white points that are left untouched in the centre; the right-hand fruit has no white spots at all now. Darken the fruit, especially the left-hand one, by drawing downwards with burnt sienna, and for the hatching use curving strokes that follow the three-dimensional shapes.

Place some soft shadows on the drawing using Prussian blue. Where the sepals have settled, you need to emphasise the shadows with powerful strokes. Work over the shadowy areas using soft terracotta hatching (see tip below).

Finally rub over your work with a damp brush. Dampen the area of the leaves you are wiping over with the brush tip. Use the kitchen paper to dab away the water. Repeat this twice until the area has become lighter. When dry, you can draw over any outlines that need defining with cobalt green and then with sienna.

Tip: Vary the pressure when hatching: go over the soft blue shadow areas with a terracotta pencil held flat, while working energetically over the dark shadow lines under the leaves.

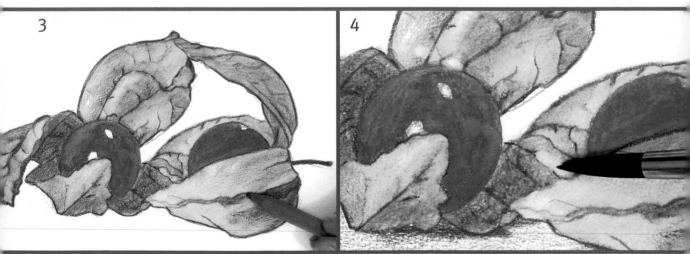

3

4

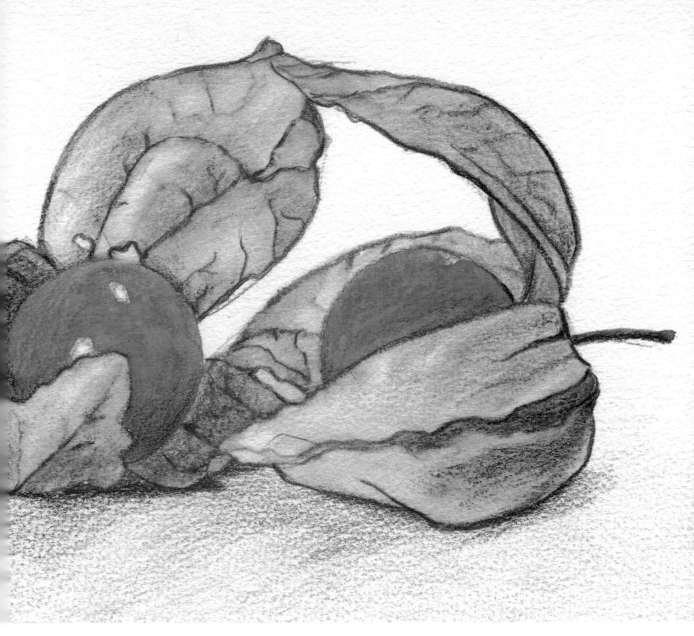

The soft assimilation of the powerful orange tones in the foreground lends the picture peace and depth. Strong reflections of light enhance the smooth surface of the fruit, which is protected by the hard edges of the leaves.

Almond blossom

Almond tree blossom has an uncomplicated beauty. It is easy to build up the five-petal shapes, even when viewed in perspective. The bright colours of the blossom are particularly fresh if you use a lot of green.

Branches

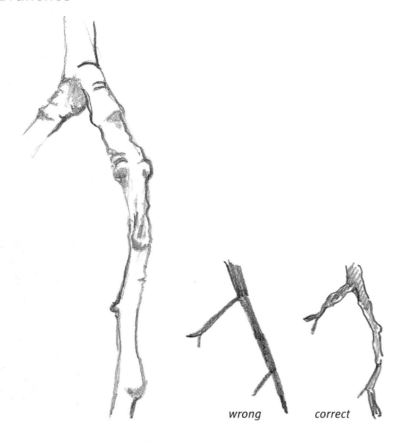

wrong *correct*

Almond branches are crooked and uneven. The bunches of blossom appear at the ends of the fine shoots in spring. Direction is very important when you draw the branches; there are frequent changes in direction, and a branch that is too straight looks unnatural. The surface of older wood often looks silvery, which is best evoked with light grey tones. You can paint the shadows on the knots somewhat darker. It is often sufficient to represent light lichen and moss using lighter and darker grey – assuming that you are drawing a very old mossy tree.

Flower structure

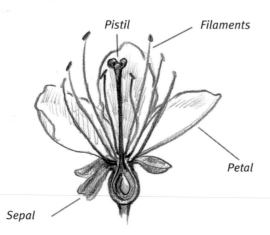

Pistil *Filaments*

Petal

Sepal

By understanding the structure of the flower you can draw it better. There are five small sepals arranged around the lower edge of the corolla. At the bud stage, the sepals enclose all other parts of the flower. They droop down when the flower opens. The five pinkish petals grow up from the receptacle. The pistil is in the middle of the receptacle, surrounded by numerous fine filaments.

Views of flowers

You need to look very closely to make the flower look alive. Do not be afraid to make lots of sketches: the flower in its different stages, the arrangement of the petals, the base of the stalk, the leaves, differing light incidences – you could fill an entire sketchbook with such studies.

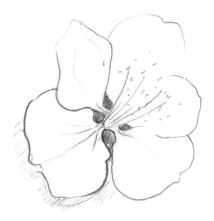 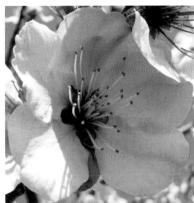

We can see the shape of the petals very clearly in the full blossom: rounded on the outside but very narrow at the base. Behind this we can see the sepals only as dark areas.

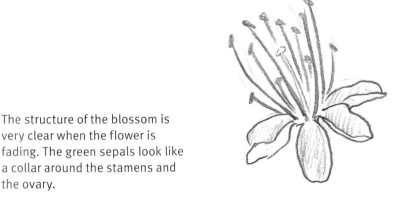 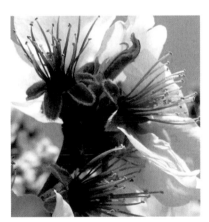

The structure of the blossom is very clear when the flower is fading. The green sepals look like a collar around the stamens and the ovary.

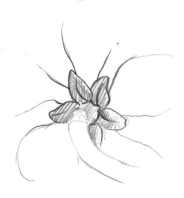 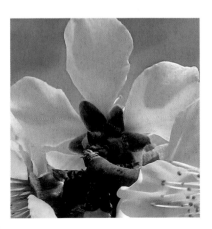

The organisation of the petals can be seen clearly from the back: the small, dark sepals are offset between the pale petals.

Basic shapes

When seen from either the front or above, the basic shape of the almond blossom is a circle. Usually we see blossoms in a bunch from an oblique angle. At this angle the basic circle becomes an oval.

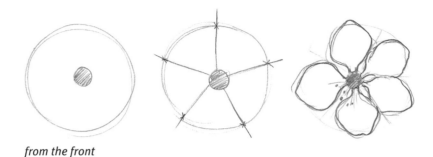

from the front

From the front the blossom can be simplified as a small circle with another small circle in the centre. You need to divide the external circle into five. Draw a line from each of the intersections to the central point of the blossom. When you draw in the shapes of the petals, the result looks very realistic.

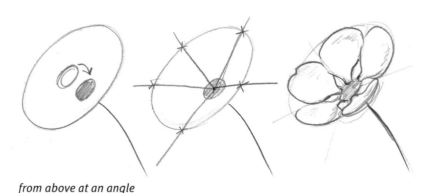

from above at an angle

To draw a flat flower, for example an ox-eye daisy, from an angled perspective, the basic shape would be an oval with the middle centred. An almond blossom has a bowl shape, however, so it is necessary for the central oval to be a little lower. Divide the basic oval into five segments, and draw the petals on top of this frame. The blossom soon looks three-dimensional with a touch of shading.

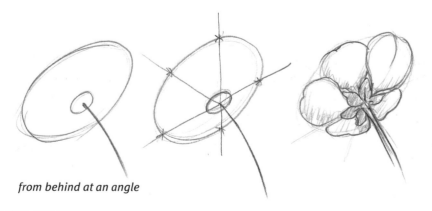

from behind at an angle

Use the same principle for the back of the blossom. The basic shape is again an oval with a shifted inner oval. First draw the petals over the five segments, which can overlap a little, then add the five sepals, which are located in the gaps.

Circles and ovals

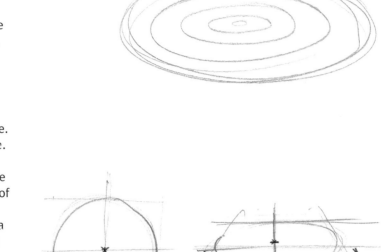

Do some free drawing of basic shapes: work with a soft pencil on scrap paper or large sheets of wrapping paper. Start with simple circles, then draw circles inside each other. Also draw ovals – the bigger, the better.

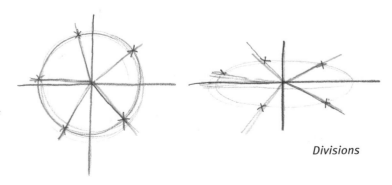

You can draw more accurately with a frame. You need to start from a square for a circle. Draw two axes, a horizontal one and a vertical one. The intersections give you the centre as well as four points on the curve of the circle.

You also need a square in perspective as a frame for an oval, which is a circle seen in perspective. Again the use of guidelines creates four intersections on the oval and the central point. Note: the horizontal axis will shift downwards a little from the middle!

Drawing frame

Practise dividing circles and ovals into five segments. Divide the circle again with one vertical and one horizontal guideline. Mark five equal sections on the circumference; follow the illustration. Draw a line from each of the marks to the central point.

Use the divisions in the circle to help you do the same for the oval. You do not have to produce mathematically correct work.

Divisions

Drawing project

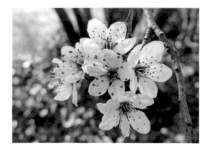

Tip: *You can also practise drawing your almond branch by copying an apple or cherry branch at home. Their branches are very similar.*

Materials: *pale green pastel paper (160g/m²) size 30 × 40cm (12 × 16in), kneadable eraser, cotton buds, soft cloth and fixative*
Pastel chalks: *sepia, white, black*

1. Draw the basic round forms of the flowers gently in white. Outline the directions of the branches. Draw the contours of the petals inside the overall shapes. Press hard!

2. Draw the contours of the petals in white. Smudge the white chalk with your finger from outside to inside.

3. Position the branch, drawing mainly the lighter parts (see the tip on the left). Leave out the dark areas for now. Rub the chalk on the branch with your finger.

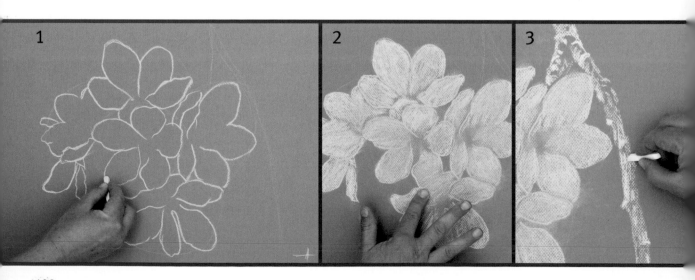

4. Indicate the pale areas in the background in white. Rub out any unwanted traces of chalk with your finger. Make a point on your kneadable eraser and use it to soften the guidelines. Also work on the centres of the flowers with the kneadable eraser. The blossom will look more solid if you remove the white from the centre (see tip on the right).

5. Gently colour all the centres of the flowers with the sepia pastel chalk. Finally smudge the brown gently with your finger.

6. Draw the dark shadows under the knots on the branch in sepia. Blow off any excess chalk. Smudge the shadows carefully with your finger. Use the kneadable eraser to remove any unwanted chalk strokes outside the branch. Dab off colour from the branch as well, if needed (see tip below).

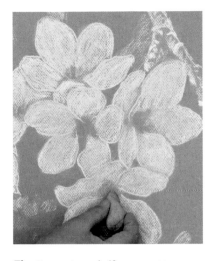

Tip: Press strongly if you want to remove a lot of colour with the kneadable eraser, and gently if you only want to remove a little.

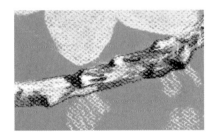

Tip: Gently turn the paper from time to time, to make it easier to work on individual parts of the picture.

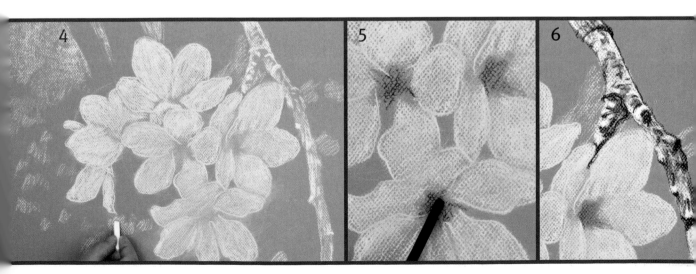

7. Draw some dark patches in the background in sepia chalk. Use a light touch as you draw the chalk over the paper. Lightly put in the branches in the top left of the background. Darken the areas in between the blossoms and in their immediate surroundings.
Rub in the sepia chalk around the blossoms with a cotton bud, to deepen the colour. Remove the rest of the sepia colour with a soft cloth, wiping towards the edges of the picture. Check the picture and then fix it in this state. Remember that you will not be able to remove any chalk after you have fixed the picture!

8. There are small spaces where the petals narrow towards the flower receptacle; the calyx at the back looks dark here. Draw over these areas strongly in black, and then smudge the chalk with the cotton bud.
Fix this.

9. Reinforce the white of the petals, and again fix this layer. Draw the filaments in white and the anthers in sepia chalk. Fix the picture for the last time.

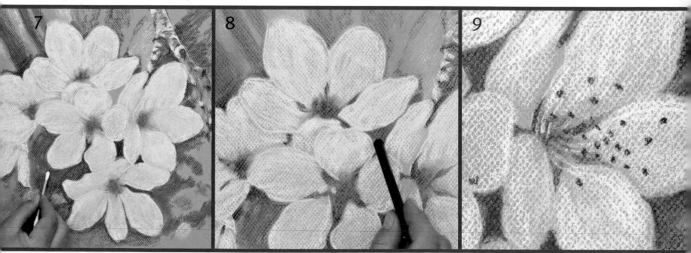

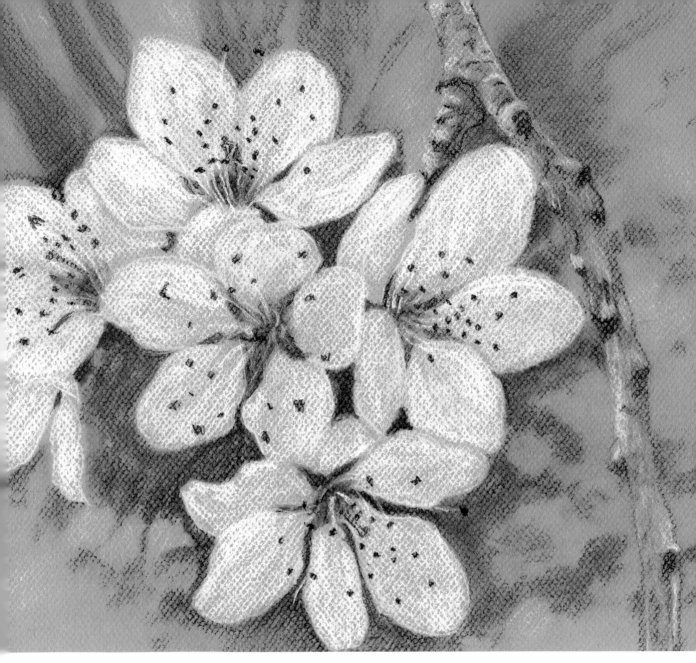

The rough, highly varied surface of the almond branch brings out the softness of the blossoms.

Rose

Roses do not need to be red: the soft petals are just as beautiful in black and white. You need to be very careful when working on opened hybrid tea roses as they are so delicate. It is best to start out with buds or closed flowers.

Flower structure

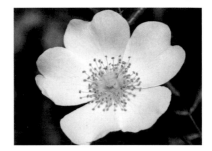

The wild dog rose has a very simple structure with five petals. If you draw the blossom from above you can simplify it into circular shapes.

Dog rose petals have heart-shaped indentations at the edges. Golden yellow stamens surround the style in the centre of the flower.

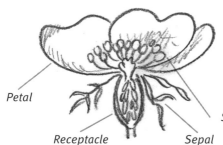

Petal

Stamens

Receptacle *Sepal*

Leaves

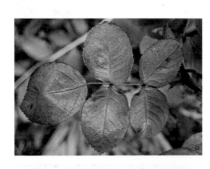

A rose leaf is formed from several small leaves with serrated edges. The central stem ends with an egg-shaped final leaf, with two to six other leaves at the sides. Two subsidiary leaves have fused with the lower part of the stem.

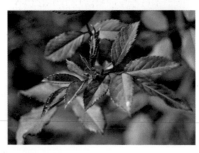

The leaves are easy to draw when viewed from above. Showing them in perspective is a little more challenging, but it is worth doing: the more twisted the leaves, the more interesting the picture.

Flower development

Five green sepals, whose ends often extend outwards, surround the bud of the dog rose. The basic form of the young bud is a teardrop, which can be broken down into a semi-circle, a circle and a triangle. Later on the growing petals will burst through the sepals and the colour of the bloom will shine through.

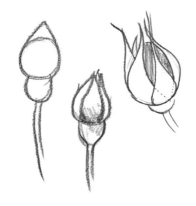

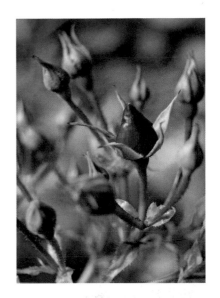

The more the bud unfolds, the less pointed its tip becomes. The sepals bend outwards. Even when the bloom is nearly closed, the petals start to gently turn outwards. The petals stick closely to the contours of the bud. The central petal is slightly indented at the top.

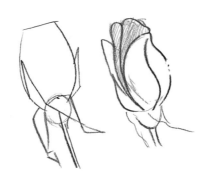

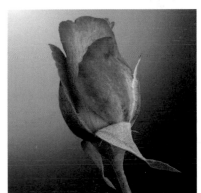

As the rose develops the petals turn outwards. The bud shape only continues in the centre, while the outer petals open out. They are arranged in an overlapping spiral. It is less easy now to distinguish the individual petals (see coloured drawing opposite).

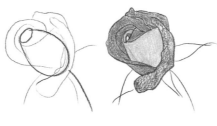

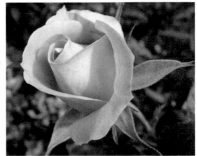

The opened bloom has a simple basic shape when viewed side-on, resembling a bowl with an oval opening. The pointed sepals are turned back and appear to dance around the base of the flower.

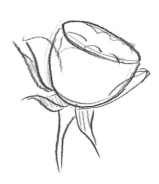

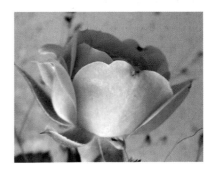

Full roses

Garden roses often have full blooms. These are varieties where most of the stamens have developed into petals. We can see the individual outer petals better by using different colours. Many outer petals are folded down their centres.

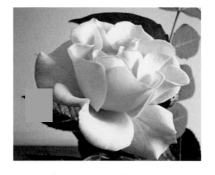

The outer petals of the yellow cultivated rose are very wavy. The basic shape resembles a cup and saucer.

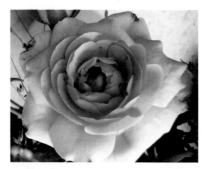

The pink flower opposite shows petals that are very dense and offset, like scales or tiles. The flower structure, with its concentric circles, is particularly clear in the centre.

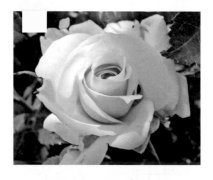

Here the middle of the flower has a narrow bowl shape with tightly wound petals. In contrast, the surrounding petals bend outwards loosely.

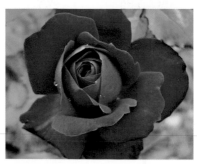

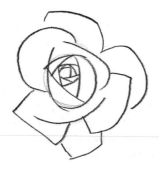

In the case of the red garden rose, a few arched petals surround a tight interior. The divisions of the centre of the flower often appear triangular. This is how roses are stylised in Art Nouveau.

Petals

Rose petals are rounded in shape. When the sides fold in they turn into an oval.

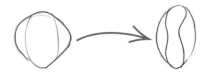

A symmetrically curled square casts soft shadows on the inside. When a rounded petal curls in the same way, we see a half oval shape on one side. The other side has a wave shape.

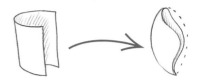

The centre of the rose bloom often has the appearance of a long piece of rolled-up ribbon.

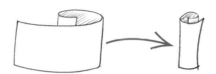

The petals turn around the centre of the flower like a vortex. On the outside there are a few smooth petals.

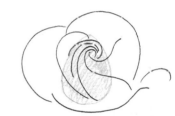

You can clearly see how the inner petals huddle close to the teardrop centre in the case of the bicoloured rose. The centre of the bloom is shown in orange in the individual drawings.

Exercise

Practise doing three-dimensional drawings. The basis of the design is a teardrop-shaped bud. You need to set up a grid of guidelines on the bud. You could place a striped pattern on it that follows these guidelines, given that patterns always follow the form of the flower. Draw a simple petal around the bud, and cover its contours with guidelines (A). Cover the bud with some more overlapping petals (B). Place a proper petal with a curved edge around the bud – you can represent invisible lines with dashes (C). After you remove the bud you need to put shading in the centre of the petal to show the hollow form (D).

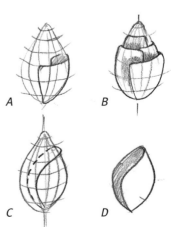

Drawing project

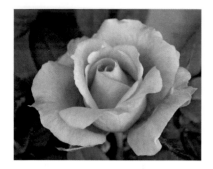

Materials: A3 sketching paper (90g/m²), 4B pencil, kneadable eraser, paper stomp or blending stick, fixative

1. Thinly mark out an area of 22 × 22cm (9 × 9in) on the paper. First make a sketch of the basic shapes of the bloom, with the teardrop-shaped centre and the inner and outer rings of the petals. Leave the background for the moment. Draw the outlines of the petals with gentle pencil lines. Make the edges wavy. Draw them straighter where the petals curl up.

2. Gently hatch the surfaces of the petals. Leave out areas which appear bright in the reference photograph. View the image with your eyes half closed, so you can see the contrasts more clearly. Apply shading accordingly. Use only light pressure. The lightest parts – for example the upper petal edges – will remain white. Add the next darkest grey-scale value, by drawing at right angles over the previous hatching.

3. Work over the curled edges of the petals, so they look somewhat rounded; for this draw small, arched strokes on the straight edges (highlighted in pink in illustration 3). Accentuate the blooms by placing the darkest areas against light areas and amplifying the contrasts. Smudge the surfaces and edges of the petals gently with your finger or with the paper stomp. Insert the stem. Work up the light points by removing the pencil work with the kneadable eraser. Clean up smudged areas, again with the kneadable eraser.
Put in the background. Drop in some leaf-shaped dark areas using gentle hatching on the bloom. This will create a better connection with the surroundings. Lightly blend the background with your finger. Finally fix the picture.

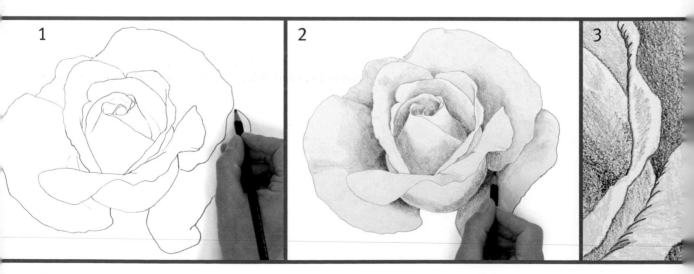

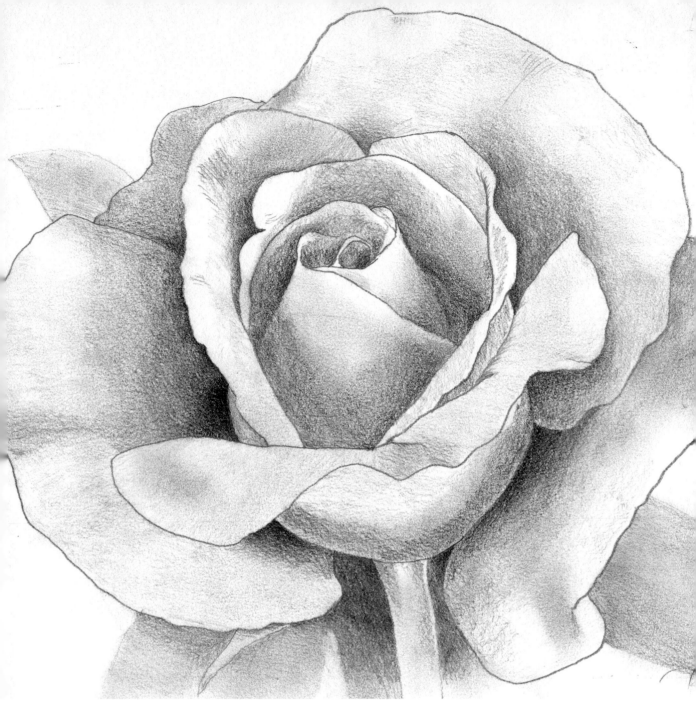

Distinct shadow structures give depth and animation, even to a rose that is only drawn in black and white: the aesthetics of the rose are preserved.

Lotus flower

The lotus has its roots in the mud, but its flowers and leaves remain clean and pure. Water drips off the lotus like pearls. The flower has harmonious shapes and colours, and the seed cup in the middle is in itself an attractive and rewarding motif.

Flower structure

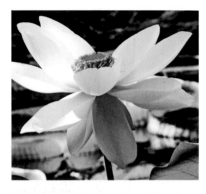 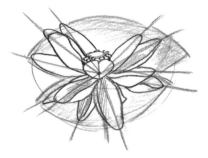

The petals of the lotus give a misleading appearance of confusion in all directions, yet you can see a pattern if you look more closely. The petals run along axes that converge in the receptacle (shown in red in the drawing). Some of the petals bend up in a semi-circle, while others bend down in a circle (blue in the illustration).

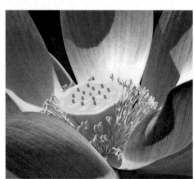

Stigma

Stamen

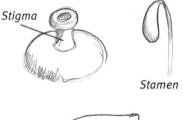

Petal

There is a bright yellow seed cup in the centre of the lotus flower. The surface of the seed cup has small protrusions, from each of which grows a stigma in the form of a large pinhead. There are numerous fine stamens around the seed cup. The petals are spoon-shaped when open.

Flower development

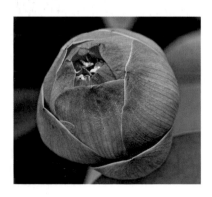 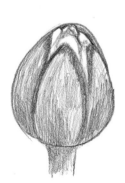

The lotus bud has a compact shape. The sepals are a glowing green with red-tinged edges. When the bud opens, pink, white or yellow petals appear.

The mature bud grows in a long teardrop shape. The individual petals are also teardrop-shaped, and overlap like scales. Look at the colour transitions. The green of the stem carries on into the sepals, turning pastel yellow and then pink with dark contours at the end. The colours are particularly splendid in front of a dark background.

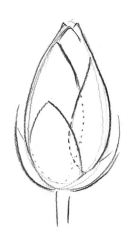

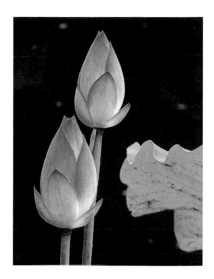

There are also attractive colour transitions in the young flowers. The petals are located on oval tracks around the central point. The rolled-up petal in the centre of the flower is pointed in shape in this simplified drawing.

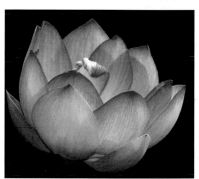

The seed cup becomes more prominent as the lotus matures. The bumps on the surface stand out more. The entire surface sinks a little, leaving a raised border around the top edge.

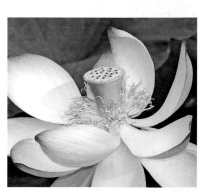

Seed cup

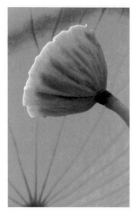

Although the young seed cup is yellow, the mature seed cup takes on a green and then a brown colouring. The stamens and petals have dropped away from the bowl-shaped seed cup. The seed cup acquires folds around its sides. The flat surface of the seed cup has a rounded shape, but from an angled perspective it looks like an oval. The rear view also has a basically oval shape. The drawing here covers both views.

Leaves

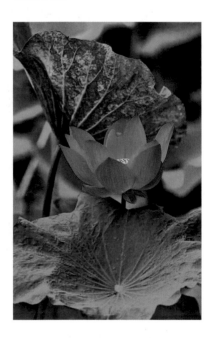

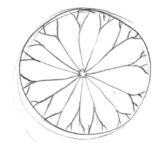

from above

If you view a lotus leaf directly from above, the basic shape is a circle. Leaf veins run in a star shape from the centre to the edge. The basic shape from an angled viewpoint is oval. As the leaf matures, the edges become wavy, which makes them more interesting to draw.

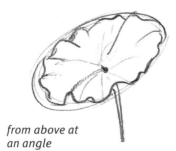

from above at an angle

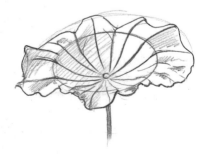
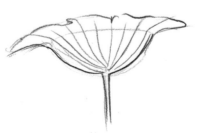

The centre of the leaf looks like a bowl, with the leaf edge hanging in folds over the edge of the bowl. This is easier to see in a cross-section.

Drawing project

Materials: handmade watercolour cartridge paper (300g/m²) size 30 × 40cm (12 × 16in), watercolour brush (no.16), cotton bud
Watercolour pencils: caput mortuum, viridian, green-gold, carmine pink, leaf green, light yellow, light green, olive green, red-violet, black, warm grey

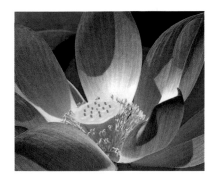

1. First reduce the lotus blossom to its geometrical forms (see tip on the right). Draw over the basic shapes of the petals with gentle strokes in carmine pink. Indicate the seed cup in light yellow. Develop the contours of the petals more precisely in the same colours and draw lines following the shapes of the leaves.

2. Paint over the petals one by one with a damp brush. Work with rapid strokes, but do not just brush here and there, or the drawing will disappear. Once the petals are dry, paint in the yellow centre of the flower. The next step is to hatch the background using leaf green and viridian. Again paint these areas with water.

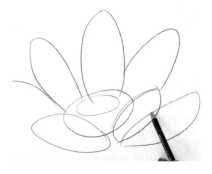

Tip: Do an initial drawing of the basic shapes using watercolour pencils.

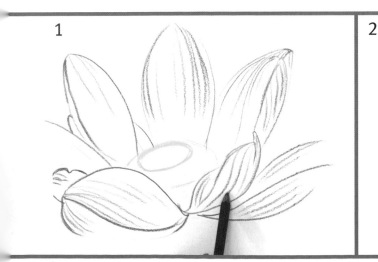

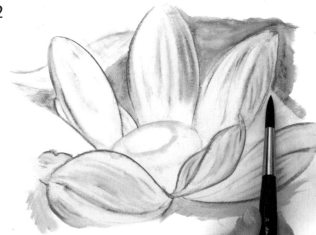

3. Indicate the stamens around the seed cup with small ovals and strokes in green-gold. Place green-gold strokes on the top of the seed cup for the stigmas. Fill the gaps between the stamens with red-violet. Draw on the shadows of the stigmas and stamens with caput mortuum. Allow some viridian from the background to flash through the gaps between the petals.

4. Work over the entire seed cup with light yellow. Shade the edge of the seed cup and the stigmas with caput mortuum. Place flat shadows on the lower-left petals using warm grey. Draw the shadows as fine grey lines.

5. Draw on carmine pink lines following the shapes of the petals. Shade the edges with strong, dense lines drawn in the same colour. Draw over the bases of some of the petals with light yellow and light green. Apply shadow areas to the petals in red-violet. Remove colour from the petal bases with a damp cotton bud. Turn the cotton bud with every stroke and replace it as soon as the head is coloured, otherwise you will transfer the colours. Pay special attention to the V-shaped bases of the petals in front of the seed cup.
Work over the background once more with viridian. Hatch over the dark areas in black, and over the light areas with leaf green and olive green. The transitions between the green tones need to be visible, but without sharp contrasts. Draw right up to the petals, so these are clearly defined (use the finished drawing on the right to guide you).

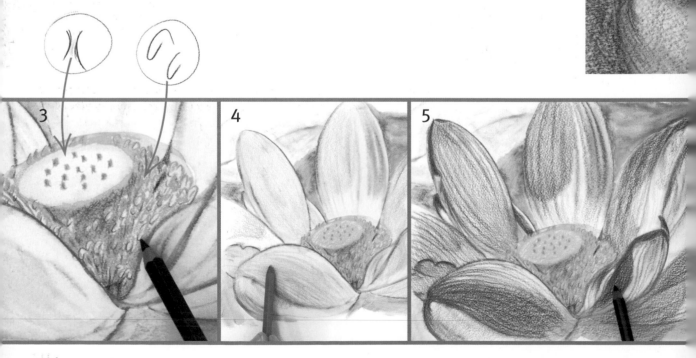

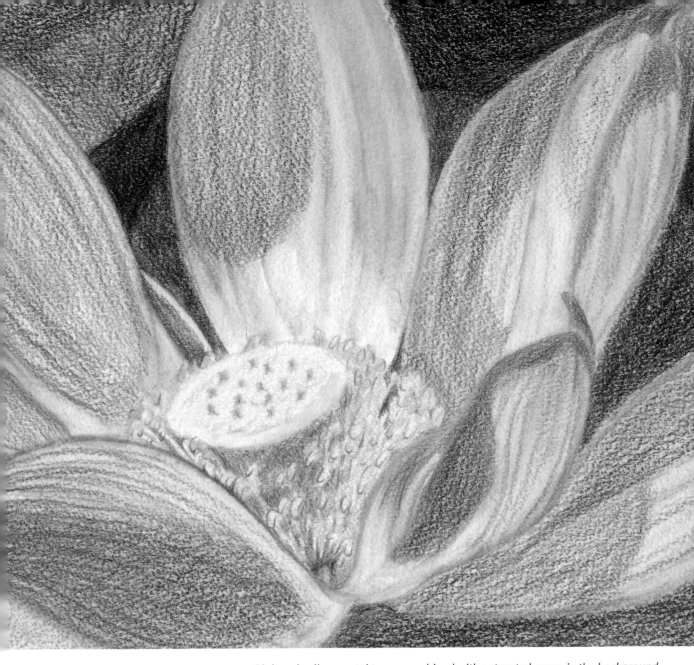

Pink and yellow pastel tones, combined with saturated green in the background, will emphasise the meaning of the lotus blossom as a symbol of life.

Orchid

Orchids are not easy to draw, on account of their many details and fine tonal gradations. If possible, buy a living plant, which you can view from every side, rather than using a reference photograph.

Shoots and buds

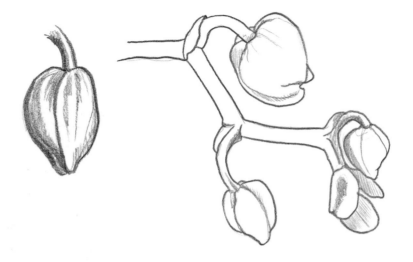

Orchid buds are lumpy and solid looking. Their strong, uniform colours give no intimation of the subtle tones of the blooms to follow. The shoots are robust and fleshy like the buds. The flower formation resembles a bunch of grapes; you may also sometimes come across single blooms. The buds and flowers are usually positioned at the ends of the shoot.

Flower

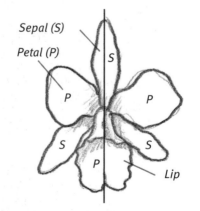

Sepal (S)

Petal (P)

Lip

The orchid bloom consists of three sepals and three petals. The bottom petal on the axis of symmetry is different from the others in colour and size, and is known as the 'lip'. Sometimes the lip grows into a bag-shaped 'shoe', or lengthens into a spur at the back of the flower.

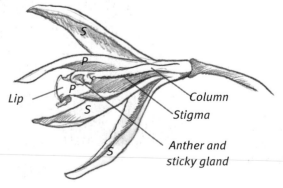

Lip

Column

Stigma

Anther and sticky gland

The vanilla plant is also an orchid! The cross-section on the left shows its flower structure: in the centre the stamen, ovary and stigma have all fused into what is known as the column. The pollen is created in the anthers at the end of the column and adheres to the outside of the sticky gland.

Lady's slipper

The lady's slipper is one of the most magnificent wild orchids and is a protected species. A lady's slipper shoot only carries one or, rarely, two blooms. The four narrow purple- to chocolate-coloured petals are twisted, which gives a very elegant impression. The bulbous, soft yellow 'slipper' has a ribbed surface.

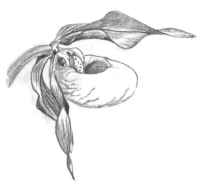

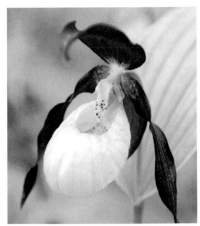

Phalaenopsis (Moth) orchid

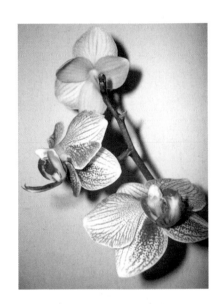

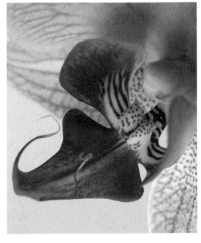

The richly varied colours and shapes of phalaenopsis hybrids make them popular indoor plants. This species originates from the tropics. A phalaenopsis stalk bears several blooms; the lip extends out to form pointed lobes. To simplify the structure of the flower formation, the drawing above has hardly any shadows.

Drawing project

Pencil drawing

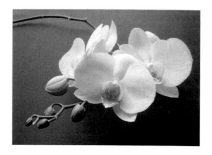

Materials: *A3 drawing paper (190g/m²), 6B pencil, paper stomp or blending stick, kneadable eraser, fixative*

1. Sketch the orchid branch with the stalks, buds and only two blooms. It is best to use only a few picture elements, in order to see the details of contrast-poor blooms more easily. Look at the reference photograph with your eyes half closed. You can start by highlighting the darkest areas with strong strokes. The rest should be only gently delineated.

2. Develop the detail within the heart of the flower and then smudge the pencil lines with a paper stomp. Look at your picture with your eyes half closed. Where are bright patches still needed? Remove the colour from these areas with the kneadable eraser. Draw the buds, and apply the first shading to them.

3. View the shadows in the reference photograph with your eyes half closed and hatch your flowers, generously but softly, holding your pencil flat. Draw some strong hatching on a piece of scrap paper and then start smudging the whole of your drawing from outside to inside with the paper stomp. If there is not enough pigment in the drawing, take some spare pigment from the scrap paper. Aim to achieve a three-dimensional effect.

Clean the background with the kneadable eraser. Make some areas brighter by removing pigment from them with the kneadable eraser. Check the effect regularly by looking through your half-closed eyes. If the kneadable eraser becomes too dirty, re-knead it until it takes up the pigment again.

Next work on the centres of the two flowers. Check the light and shade all over. Pay attention to the details. If need be, work again with the paper stomp and remove marks with the kneadable eraser. Finally fix the picture.

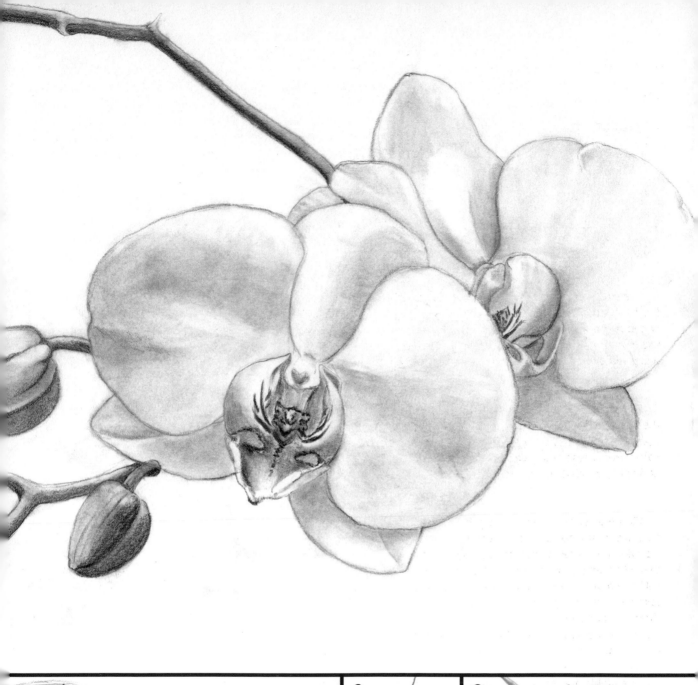

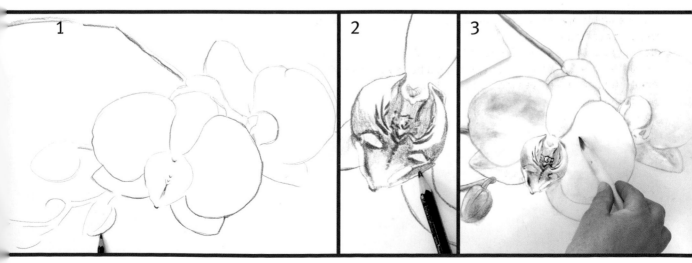

Drawing project

Colour pencil drawing

Materials: *A3 drawing paper (190g/m²), 4B pencil, kneadable eraser*
Colour pencils: *dark red, earth green, cadmium yellow, light yellow, light green, walnut brown*

Tip: It is always a good idea to capture the basic shapes of an image in advance. This will help you to organise the picture and to determine the proportions.

1. Sketch the main contours of the blossom branch with your pencil (see illustration and tip on the left for this). Sketch the stalks, buds and only two blooms. It is best to use only a few picture elements, to make the details of the contrast-poor blooms stand out more clearly. For the preliminary drawing use a rather blunt pencil, with circular movements and without pressure. Draw in the centres of the flowers in light yellow, with light green for the buds and stalks, as well as the deep parts of the central flower. Shade the buds and stalks with earth green. You will generally not use any blending during this drawing project. Instead you can use hatching to give the image its three-dimensional form.

2. Shade the tip of the left-hand bud with dark red (see detail below), and shade all the green parts of the buds in walnut brown. Look very closely, and always check the contrasts with your eyes half closed.

Detail: Work on only a few buds, adding dark red accents.

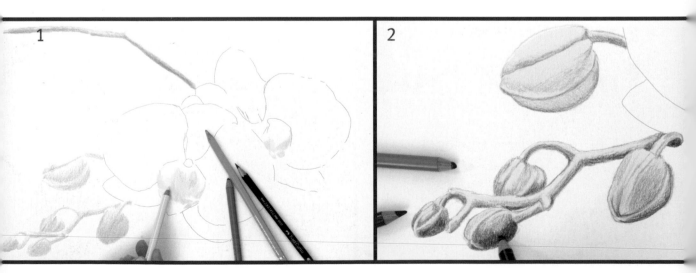

3. Work on the centres of the flowers with a strong application of cadmium yellow. Draw the patterns and edges in dark red. Shade the centres of the flowers with the pencil, and draw gently over the colours (see tip on the right). Be sure to maintain the light–dark contrasts. To see the contrasts more clearly, view your image frequently with your eyes half closed.

Shade the shadows on the petals by holding your sharpened pencil very flat. It is not so easy to make out gentle shadows. Take a step back, and view your picture and your model orchid through half-closed eyes.

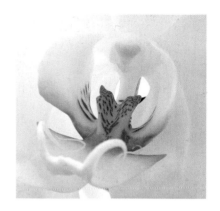

4. Because orchids are white and not easily distinguishable from the paper, darken the background around the blooms a little. Lighten the pencil contours first with the kneadable eraser, then shade the contours with a flatly held pencil.

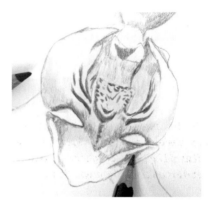

Tip: Use the close-up photograph to guide you when drawing the details of the centre of the flower. Always take some breaks from drawing along the way.

Tip: Hold your pencil loosely and right at the end. This helps you apply pigment more finely.

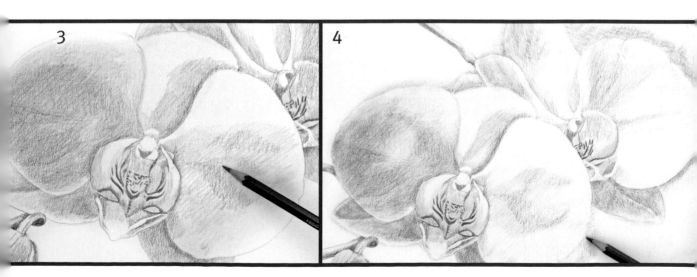

5. Accentuate the buds and stalk again with a pencil. Examine them closely. It is important to work up the light and dark areas, to give a three-dimensional effect.

6. Check the tonal values in the overall picture. If you stand back and view it at a distance, you may find that the buds are competing too strongly with the flowers. If this happens, reduce the bud tones with the kneadable eraser (see tip below). If the blooms are too light on the inside, shade across the centres of the flowers and the lower petals with a broadly held pencil.

Tip: *Try to work evenly if you are lightening different areas with the kneadable eraser.*

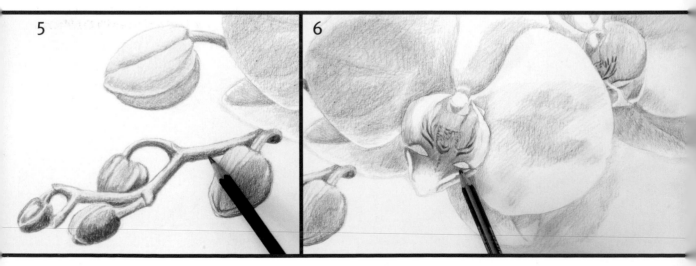

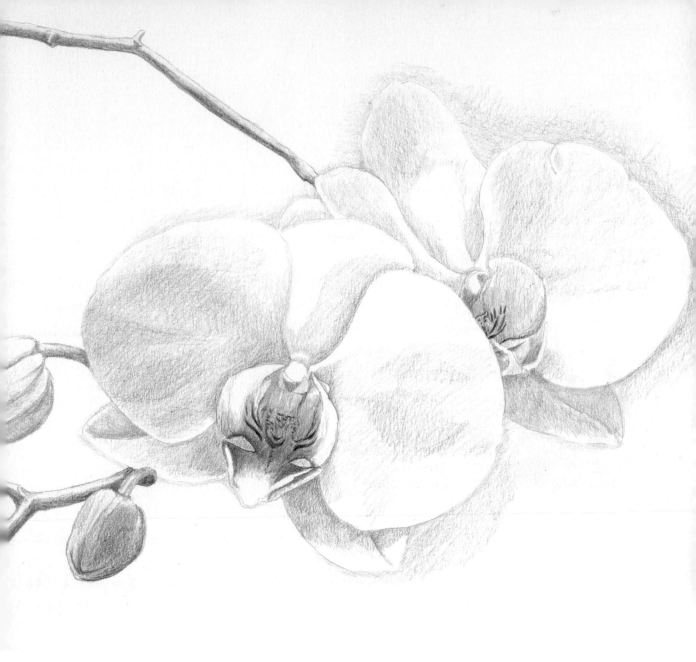

Discreet colouring is consistent with the nature of these superb orchids. The buds should have only a little colour, so they will not compete with the blooms.

Credits

Design, text, photographs and drawings: Anne Pieper
except for p 10 lower left, 14 upper right, 15 upper left,
centre + bottom, 18 top, 19 top, 24 bottom: Cordula
Kerlikowski; p 11: Lyra Bleistift GmbH; p 16, 18 centre
left, 19 bottom: Dirk Dzimirsky; p 20: Dörte Gerasch; p
17 top left: Erika Schuler-Konietzny, p 40 and 106–109:
Christiane Pieper (drawings)

All the following photographs are from www.Pixelio.de:
www.Pixelio.de (p 47; 86 bottom; 99 top + bottom; 102;
114; 115); Ulikat (p 30), Steffi Pelz (p 32 top); Sparkie
(p 32 centre); Kurt Michel (p 32 bottom); Marquis (p 33);
GerdaB (p 35); Angelika Lutz (p 27; 37 top; 95);
Knipseline (p 38); Torsten Lohse (p 40 top); Martina
Taylor (p 40 bottom); Claudia Hautumm (p 41 top);
Michael Berger (p 41 centre); Marco Barnebeck (p 50 top
left; 64 centre; 87 bottom); dinolino (p 50 bottom);
S. Schlunkes (p 52); Miest (p 62); Helgard Ahrens (p 64);
Verena N. (p 64 bottom; 119 bottom); Nathalie 1984
(p 65 top); Michael Bandy (p 68); Günther Dotzler (p 68);
N. Schmitz (p 72); Kunstart:net (p 73 very top; 112 top;
114 top right); Dieter (p 73 centre 2, 74 bottom); Echino
(p 73 bottom); Joujou (p 74 top); Moschnifoto (p 74
centre); Helga Schmadel (p 75); Gabi Schönemann
(p 80; 107 centre bottom); Thomas Müller (p 85);
Hanspeter Bollinger (p 86); Domino (p 86); Dorie (p 86);
Angelika Lutz (p 87); Macrohelmut (p 93 top); Alila (p 93
bottom); Berwis (p 94 top); Kellermeister (p 94 bottom);
P. Kirchhoff (p 106 top); Espana Elke (p 107 centre top);
Bitt Berlin (p 107 bottom); Brit Berlin (p 108 top + centre
top); Angelika (p 108 centre bottom; 110); Liane (p 108
bottom; 109); Günther Dotzler (p 112 centre); Dieter
Wendelken (p 112 bottom); Haiefan (p 113 top); Ernst
Rose (p 113 centre + bottom); Maren Beßler (p 114 top
left); Steffi Pelz (p 119 top); Ernst Reisig (p 119 centre);
Samy 13 (p 120; 122); Klicker (p 123)